IMAGES
of America

LEWIS COUNTY

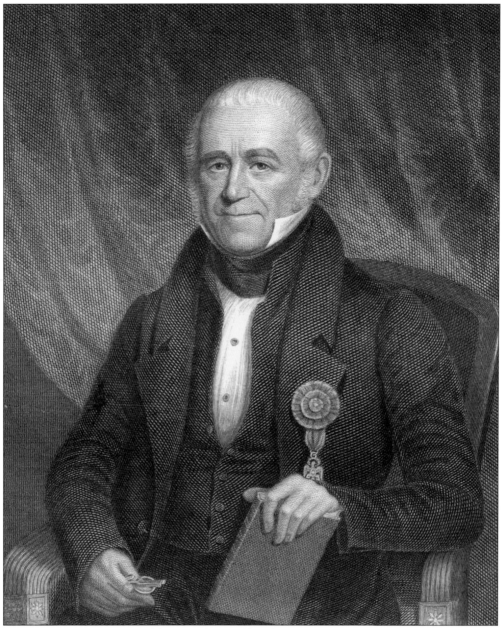

In 1805, Gov. Morgan Lewis (1754–1844) signed legislation creating Lewis and Jefferson Counties from Oneida County. (Author's collection.)

ON THE COVER: The cover features a dragsaw in John Bacon's basket factory. In 1932, Bacon set up a factory on South Street, in Lowville, to manufacture fruit baskets from Tug Hill hardwoods. The factory was conveyed to Lowville Veneer Co. in 1950. (Lowville Historical Society.)

IMAGES
of America

LEWIS COUNTY

Harney J. Corwin

ARCADIA
PUBLISHING

Published by Arcadia Publishing
Charleston, South Carolina

Printed in the United States of America

Library of Congress Control Number: 2012934348

For all general information, please contact Arcadia Publishing:
Telephone 843-853-2070
Fax 843-853-0044
E-mail sales@arcadiapublishing.com
For customer service and orders:
Toll-Free 1-888-313-2665

Visit us on the Internet at www.arcadiapublishing.com

*This book is dedicated to my friend and fellow researcher
Larry Myers, who has worked assiduously to preserve
historic images of Lewis County for future generations.*

CONTENTS

ACKNOWLEDGMENTS

I would like to thank the following individuals for their assistance and material contributions, as well as their helpful advice and encouragement: Sue Adsit, Loretta Alexander, Richard Anclam, David Andalora, Jill Bolliver, Charmaine and John Campany, George Cataldo, Lois Compo, George Davis, Vincent Fitch, Ed Fynmore, Dawson Grau, William Hamblin, Bob Hindman, Rita Higby, Shirley Joslin, Paul Joslyn, Laura Anne Markham, Ann McConnell, Dawn Myers, Larry Myers, Mark Paczkowski, Jerry Perrin, Joanne Sattler, Gerald Schaffner, Fred Snyder, Thomas Stocklosa, Shirley Van Nest, Arnold Weber, Bob Williams, Ed Yancey, Arlene Yousey, Elaine Yousey, and Ross Young.

And I would like to extend my gratitude to the following organizations: Adirondack Mennonite Heritage Farm, American Maple Museum, Black River Canal Museum, Climax Manufacturing Company, Croghan Free Library, Town of Diana Historical Museum, Lewis County Historical Society, Lowville Free Library, Lyons Falls History Association, Town of Turin, Town of West Turin, and the William H. Bush Memorial Library.

INTRODUCTION

At approximately 1,297 square miles in size, Lewis County comprises a large part of New York State's "North Country." Lewis County is topographically defined in relation to Black River. This 125-mile-long stream traverses Lewis County from south to north, dividing it into nearly equal but clearly distinct parts. East of the river is the ancient Adirondack forest, climax woodland composed predominantly of broadleaf trees, such as maple, birch, and beech, interspersed with evergreen. Away from fertile land near the river, the soil grades into a sandy loam that sits atop metamorphic rock typical of the Canadian Shield. West of Black River is the Tug Hill Plateau; these highlands, which rise to a height of 2,000 feet, also support a deciduous forest, but the soil here is mostly glacial till. Though laden with fieldstones and boulders, the topsoil has a high organic content and is suitable for farming. The bedrock of Tug Hill consists of limestone, shale, and sandstone—evidence of primeval seas that once covered the area.

Following the American Revolution, the Black River Valley remained closed to settlement. That changed in 1788, when the Oneida Nation, a branch of the Iroquois Confederacy, ceded most of its ancestral land to New York State. Wishing to populate the North Country and monetize its holdings, the state sold some 3,800,000 acres, including all of Lewis County, to Alexander Macomb for about 8¢ an acre. Although Macomb made the purchase in his name, he had entered into undisclosed partnership with fellow Irishmen William Constable and Daniel McCormick. Upon suffering bankruptcy in 1792, Macomb conveyed his interest to Constable for £50,000. Constable's land in Lewis County consisted of five large parcels east of Black River and four west of Black River.

The newly opened land was advertised in New England and attracted a trickle of immigrants from that region. Between 1794 and 1804, Yankees settled sparsely in all nine tracts but tended to favor the highlands between Talcottville and Martinsburg, as well as the rich bottomland around Leyden and Lowville. In 1804, influential citizens met at Freedom Wright's Tavern in Denmark, where they drew up a petition asking the state to form two new counties, Lewis and Jefferson, from Oneida County. The petition was granted the following year, with Lewis County taking its name from Gov. Morgan Lewis, who signed the enabling legislation. From the original five townships of Harrisburg, Leyden, Lowville, Martinsburg, and Turin, another thirteen would eventually be formed. Population increased slowly throughout the 19th century, however, and only 10 of the 18 townships would ever have an incorporated village. Between 1800 and 1810, the county's population grew from 1,362 to 6,433, and in 1880, the population reached a historic peak of 31,416.

While visiting Paris in 1792, Constable met with Pierre Chassanis, who was interested in establishing an overseas sanctuary for Royalists who wished to escape the horrors of the French Revolution. At the time, Louis XVI was imprisoned, Robespierre ruled, and terror would prevail for the next two years. Acting on behalf of the Castorland Company, Chassanis agreed to purchase 630,000 acres from Constable and sell them to investors in 100-acre shares. Enthusiasm for the

project was disappointing, however, and the Castorland Company satisfied itself with the purchase of 210,000 acres. When its charter expired in 1814, the Castorland Company had attracted only a handful of settlers to the North Country. Surrounded by a great, dark forest, the French colonists found the land difficult to clear and the climate unexpectedly harsh. Following Napoleon's ascent to power and the moderation of violence in France, many émigrés returned home.

English and Scotch-Irish pioneers from New England faced the same hardships as their French counterparts, but with more farming experience, they generally succeeded in wresting their livings from the land. With axe, fire, oxen, and family support, a pioneer farmer might clear between five and ten acres of land over the course of a year. Yankee farmers planted fields with familiar grains, but the harvests often disappointed. The humble potato, native to the Andes, was one crop that thrived. In general, the first two generations of settlers in Lewis County found life hard and prosperity elusive. Winters in the North Country tended to be more severe than those in New England, and the growing season was extremely short.

The long-term prospects for farming did not appear promising, but the outlook began to change in the 1830s with the arrival of German, Alsatian, and Swiss immigrants. These newcomers, who were familiar with farming in a subalpine climate, realized that Lewis County was perfectly suited to dairy farming. Yankee settlers had approached dairy farming in a rather desultory manner. In contrast, the new, German-speaking settlers closely attended to the diet and welfare of their herds, developing adequate pasturage for their animals and seeking to improve production. By the 1840s, dairy products—particularly cheese and butter—had become the dominant agricultural commodities in Lewis County. Before long, farmers began taking an interest in blooded animals.

As the dairy industry was becoming established, so, too, was the forest industry. Commercial exploitation of the forest was minimal until the mid-1840s, when large tanneries began to appear, primarily in the eastern half of Lewis County where hemlock and water were plentiful. By the 1850s, New York had become the center of the American tanning industry, and the tanneries at Port Leyden and Moose River Settlement were soon among the largest in the country. New York had also become the lumber capital of the nation. In the early days of settlement, a small sawmill was sufficient to meet a community's building needs. With the arrival of better transportation in the 1850s, entrepreneurs built new and larger sawmills to produce dimension lumber for the expanding cities of the Northeast.

After the Civil War, mills increased their production by adding gang saws and replacing waterpower with steam power. At the time, paper was chiefly made from rag fiber, but as paper manufacturers learned how to produce pulp from wood fiber, paper mills quickly sprang up in the Black River Valley. To satisfy the huge demand for softwood pulp, paper companies began harvesting spruce throughout the county, and logging became an important seasonal activity. Current maps of Lewis County still record the names of communities that once formed around remote sawmills and have since vanished without a trace.

Today, Lewis County remains predominantly rural. With its 27,087 inhabitants, Lewis County has a population density of 21 persons per square mile, making it the second least-densely populated county in the state. Lewis County has no cities and only seven stoplights. The ancestry of today's population reflects the various waves of early settlement, with 29 percent claiming German heritage, 14 percent French, 13 percent Irish, and 9 percent English. Despite heavy logging over the past 150 years, well over half the land is currently wooded and largely uninhabited. The tanneries are long gone, but the manufacturing of paper, cardboard, and wood-fiber packaging remains important, as does the manufacturing of other value-added forest products. Approximately one-fifth of the land is agricultural, and dairy farming continues to be the leading source of employment. Cows outnumber people, and dairy farming is increasingly dominated by large-scale operations, especially in the Black River Valley. Artisan cheese making continues to grow in popularity, but the cooperative cheese factories of the past have been replaced by a few large cheese processors.

One

NORTHEAST LEWIS

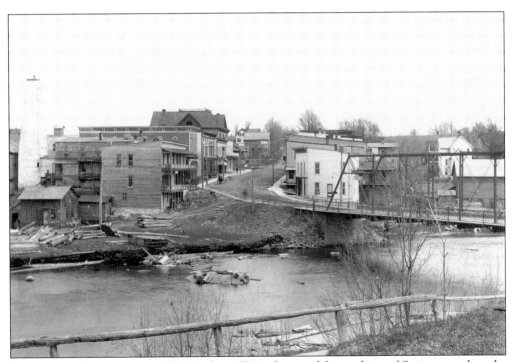

In 1815, Joseph Bonaparte—elder brother of Napoleon and former king of Spain—purchased a large tract of land from James Le Ray, part of which became the town of Diana. Harrisville, the largest community in the township, takes its name from Foskit Harris, who settled there in 1833. When early settlers discovered that detested landlord John LaFarge had acquired title to Bonaparte's land, they abandoned the area and Harrisville languished for 20 years. (Ross Young collection.)

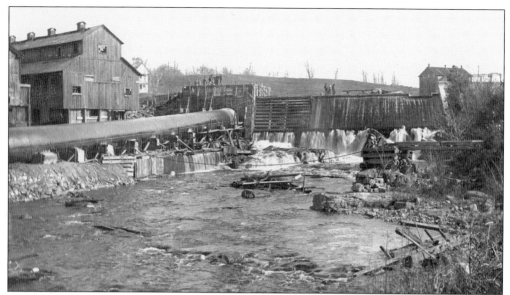

Harrisville is located near the junction of the Middle and West Branches of the Oswegatchie River. In 1859, Samuel H. Beach and William R. Dodge built a massive tannery on the east side of the river (pictured at left). The 228-foot-long structure had 160 vats and was capable of turning out 40,000 sides of sole leather per year. In 1879, David Botchford and Co. acquired the tannery, which remained a going concern until 1902. (Ross Young collection.)

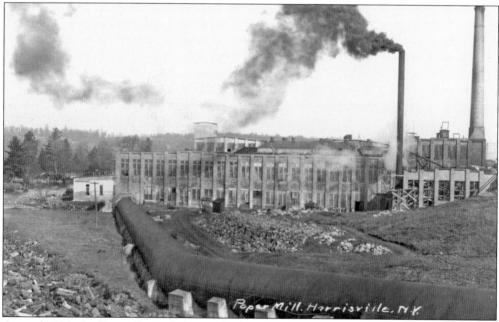

Around 1905, the Diana Paper Company built a mill on the former location of the Botchford Tannery. The mill primarily produced paper for magazines and catalogs. During World War I, the company experienced financial difficulty because of unfavorable wood contracts. After years of struggle, the company finally filed for bankruptcy in 1927. St. Regis Paper Company acquired the mill and ran it until 1954, when the Harrisville Paper Company bought it. The mill ceased operations in 1957. (Larry Myers collection.)

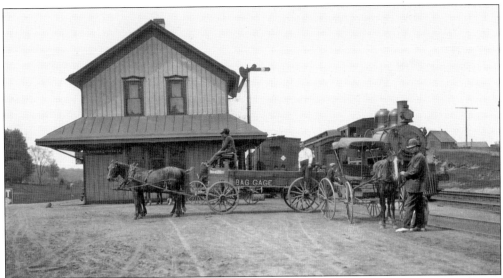

The Carthage & Adirondack Railroad came to Harrisville in 1887, replacing the earlier, unsuccessful Black River & St. Lawrence Railroad, which had relied on maple rails to support heavy locomotives. The Carthage & Adirondack transported leather, lumber, and paper from Harrisville mills. As a common carrier, the railroad also brought visitors to Lake Bonaparte and other vacation spots in the Northwestern Adirondacks. The depot is now home to the Town of Diana Historical Museum. (Ross Young collection.)

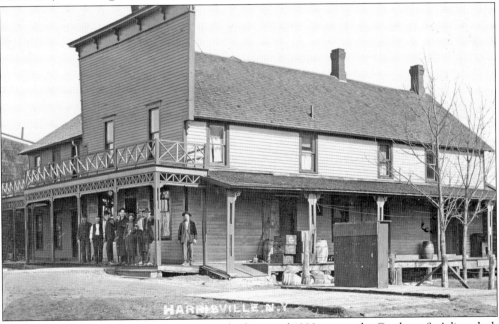

Harrisville's Pleasant View Hotel (above) was built around 1888 next to the Carthage & Adirondack Railroad Depot. In 1902, Reuben Crowder purchased the hotel from Elizabeth Saltzman and ran it until 1908, when Emory Kinsman began renting it. The Pleasant View Hotel catered to tanners, woodsmen, and employees of the Diana Paper Company. Opposite the Pleasant View, on the other side of the tracks, was the Maple Street Hotel, also known as the "White Elephant." (Ross Young collection.)

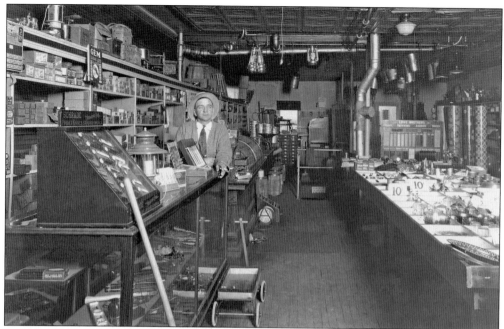

In 1920, H.J. Corbitt, Fred Kimball, and James Humes organized the Harrisville Hardware Company with $20,000 in capital stock. Here, Ross Bassette stands behind a glass case on top of which are pocket knives, a gas lantern, and fishing lures. During the 1930s, Bassette's brother George ran a gas station next door. The station was built on the site of the old Kenwood Hotel, which burned down when a great fire destroyed much of the business district in 1914. (Town of Diana Historical Museum.)

Local merchants cultivated a loyal clientele by delivering ice, milk, and groceries to area residences. To compete with merchants in the Harrisville area, the Great Atlantic and Pacific Tea Company also delivered groceries. As a chain, A&P was able to buy commodities in bulk, produce its own brand of groceries, and standardize the quality of its goods. The horses are wearing fly nets and ear coverings to protect them from stinging insects. (Town of Diana Historical Museum.)

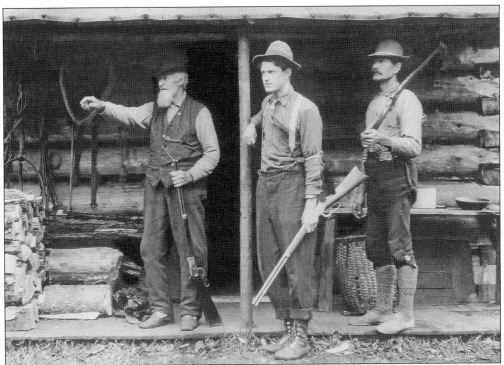

In this 1912 photograph taken at Wolf Lake, North Woods hunter and trapper Warren Humes (1830–1916) points out an item of interest to his sons Burton (center) and Myron (right). In 1832, Warren's parents, Lyman and Emeline, moved to the Harrisville area from Philadelphia, Jefferson County. Over the course of his long life, Humes reportedly killed more than 4,000 deer and 900 bears, as well as numerous panthers, wolves, and other wildlife. (Town of Diana Historical Museum.)

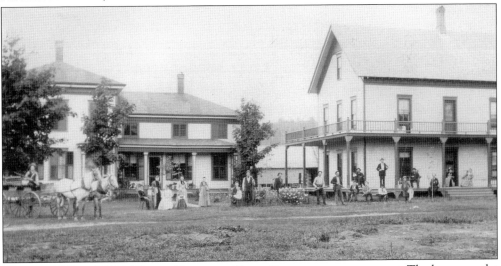

Between 1889 and 1914, Warren Humes ran Forest Home as a summer resort. The house on the left was built in 1870, and the structure on the right was erected in the 1890s. The resort had a dairy farm, a 450-acre sugar bush, and 30,000 acres of leased land. The going rate for a stay at Forest Home was $10 a week. (Town of Diana Historical Museum.)

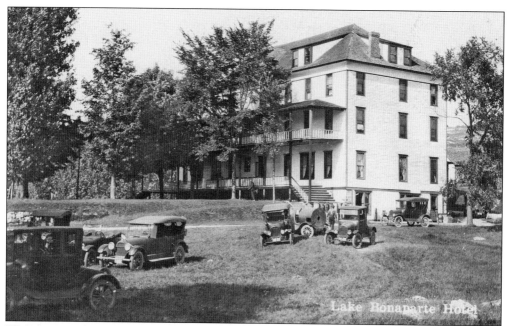

With its 24 miles of shoreline and excellent fishing, spring-fed Lake Bonaparte has long been a popular resort area. The Hermitage Hotel, on the north shore, was one of the better-known hotels. The hotel's name commemorates the hunting lodge that Joseph Bonaparte built on a bluff overlooking the lake. David Scanlon of Watertown, in partnership with Joseph Pahud, built the original Hermitage Hotel. That structure burned down in 1900, but a New Hermitage Hotel (pictured above) opened for business two years later. (Larry Myers collection.)

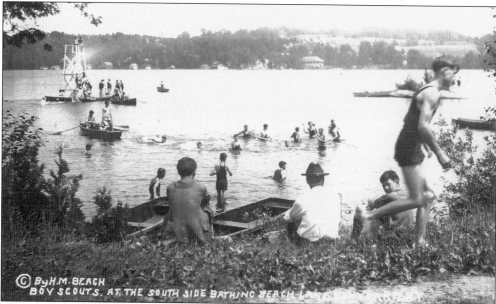

The Jefferson-Lewis Council of Boy Scouts ran Kamp Kamargo between 1921 and 1946. The camp had 41 acres of land, with 150 feet of shoreline on the south side of Lake Bonaparte. As private camps began to crowd the lakefront, the Boy Scouts moved to the more isolated Camp Portaferry, near East Pitcairn, St. Lawrence County. (Town of Diana Historical Museum.)

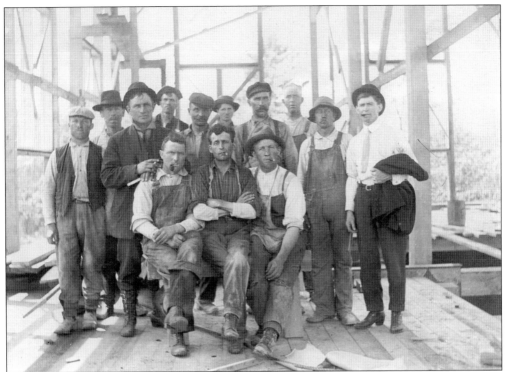

The northern portion of Diana lies in the transitional zone between the St. Lawrence lowlands and the Adirondack highlands. The bedrock in this area is both geologically complex and commercially important. After discovering a massive deposit of talc at his Natural Bridge silver mine, Enoch Cleveland formed the St. Lawrence Talc Company in 1906. Ten years later, the firm became Carbola Chemical Company. This photograph shows a crew constructing the Carbola plant. (Town of Diana Historical Museum.)

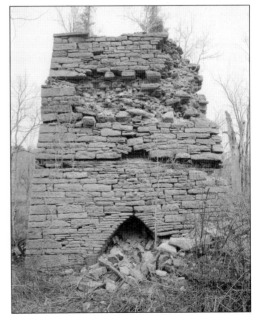

Lewisburg, with its largely Irish population, was once a thriving industrial community. In 1836, Isaac Lippencott, Joseph Morgan, and David Reamer began operating a blast furnace at Lewisburg. The firm imported iron ore from St. Lawrence County and produced about three tons of smelted metal daily. In 1850, James Sterling purchased the property and, during his tenure, changed the settlement's name to Sterling Bush. He continued smelting until 1863, when he sold the operation to Edward B. Bulkley, who carried on for another 18 years. (Author's collection.)

Col. Zebulon H. Benton owned lead mines at Rossie and iron mines at Jayville and Clifton. Believing that Alpina, located at the outlet to Lake Bonaparte, might become an industrial center, Benton purchased two blast furnaces built in 1847 and organized the St. Regis Mining Company, but his enterprise suffered from a lack of locally available high-grade ore. Married to Charlotte, daughter of Annette Savage and Joseph Bonaparte, Benton admired all things Napoleonic, as this pose suggests. (Town of Diana Historical Museum.)

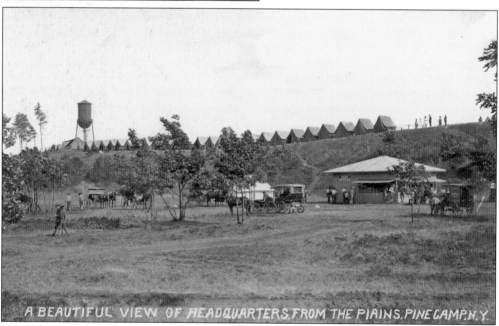

In 1940, Congress appropriated money to purchase 75,000 acres of submarginal land for the purpose of expanding Pine Camp (now Fort Drum). The annexation included part of the Town of Diana, including the hamlets of Lewisburg, Indian River Lake, and Alpina. This photograph shows Pine Camp as it appeared around 1910. The building at center right is the post office. (Lyons Falls History Association.)

"Huckleberry Charlie" Sherman (1844–1921), of Great Bend, picked blueberries, peddling them to locals with the cry, "They're free from sticks, stones and bruises, though some are black and some are blue. Come up, kind people, and purchase a few, for this is my last time through." Known as the "Sage of Pine Plains," he was one of the most widely recognized figures in the North Country. In the Henry M. Beach photograph at right, Sherman vends newspapers at the Pine Camp Post Exchange. (Lyons Falls History Association.)

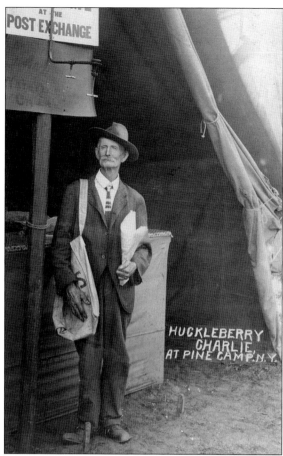

In 1792, Peter Chassanis, agent for the Castorland Company, purchased 210,000 acres along the eastern bank of Black River. This tract of wilderness was to serve as a refuge for those wishing to escape the tumult of the French Revolution. In 1795, the company decided to locate its chief settlement at Castorville (now Beaver Falls) on Beaver River. When the company's charter expired in 1814, only about 20 French families had settled in the area for any period of time. (Larry Myers collection.)

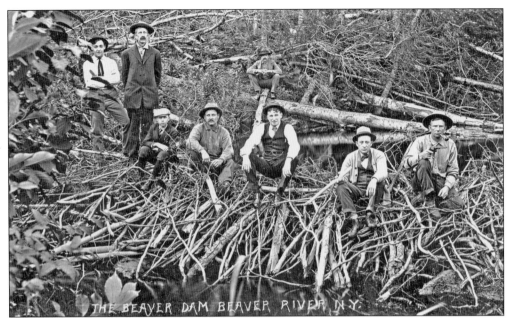

Chassanis named his tract "Castorland" after a notation on a map indicating the presence of beaver and otters in the region. (*Castor* is French for "beaver.") By the mid-1800s, beaver had become nearly extinct in New York, and in 1895, the state legislature designated the animal a protected species. In the next decade, the Forest, Fish, and Game Commission began restocking the Adirondacks, and by 1915, beaver was once again found in Lewis County. (George Davis collection.)

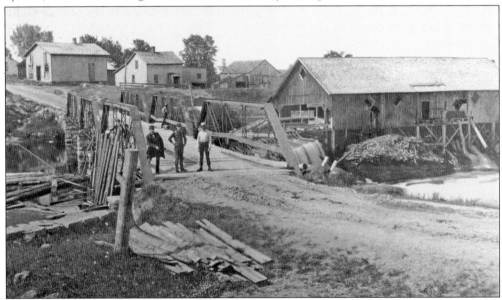

The Erie Canal, which opened in 1825, lured settlers westward, causing land sales to falter in the North Country. Nonetheless, James Le Ray and his son Vincent, who had acquired large portions of the Castorland Tract, succeeded in attracting immigrants to Beaver Falls from Alsace-Lorraine and neighboring parts of Germany and Switzerland. Among the first were Jacob and Rudolf Rohr, who erected a sawmill on the north side of Beaver River. Aaron Foote built a sawmill (pictured above) on the south side. (Lewis County Historical Society.)

Many of the German-speaking immigrants were Amish Mennonites seeking freedom from military conscription as well as the right to own land. Unlike the French who had preceded them, these settlers prospered—first as farmers and later in commerce. John Moser, who arrived in 1833, was among the early Amish Mennonites who settled in the Beaver Falls–Croghan area. His namesake, John B. Moser, and Mary Yousey Moser are pictured in 1957 on their 50th wedding anniversary. (Arlene Yousey collection.)

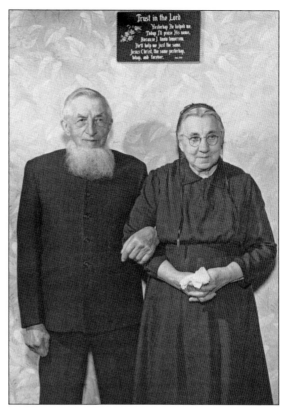

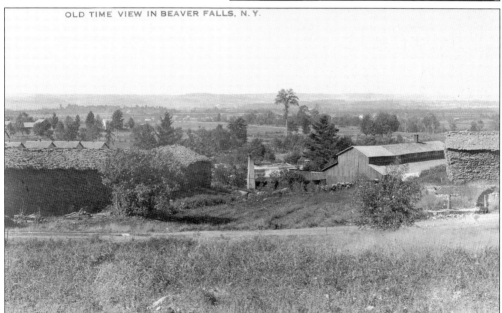

In 1851, Hiram Lewis built a tannery at Beaver Falls. His son, J.P. Lewis, along with Martin R. LeFevre, acquired the tannery in 1871 and continued to operate it until 1894, when the local supply of hemlock had become depleted. In the photograph, piles of hemlock bark are stacked in long shed-like piles for drying. (Lewis County Historical Society.)

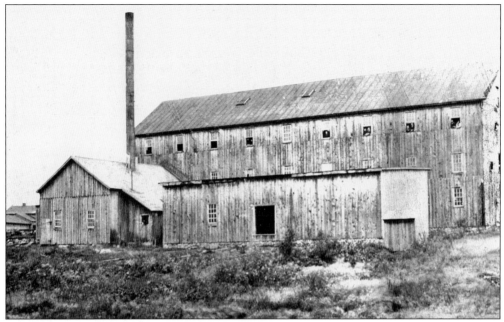

In 1881, the citizens of Beaver Falls built a two-story structure measuring about 150 by 50 feet. The community leased the structure to W.H. Hiss, who owned the Smith and Stephens Company, a manufacturer of wooden and paper plates. In 1887, a lamp exploded, burning the plate factory and putting some 40 people out of work. (Lewis County Historical Society.)

J.P. Lewis (1845–1912) was a driving force in the economic development of Beaver Falls. During his life, Lewis formed three companies. Lewis and Slocum Co. manufactured pulp board and waterproof paper for use in construction; Lewis, Slocum, and LeFevre Co. produced wood pulp for the Lewis and Slocum mill; and J.P. Lewis Co. manufactured wood products until 1932, when it joined with United States Rubber to form Latex Fiber Industries, a firm specializing in composites of wood fiber and rubber latex. (Lewis County Historical Society.)

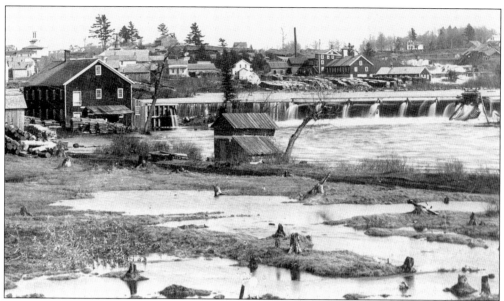

In 1881, J.P. Lewis, with his brothers-in-law Martin R. LeFevre and Charles Nuffer, built a dam at Beaver Falls and erected the Pine Grove Pulp Mill (dark building at left). By 1886, with the plant failing and his partners discouraged, Lewis acquired sole control and soon turned the business around. Upstream is the Riverside Pulp Mill and, just to the left of that, the Lewis and Slocum Paper Mill. This photograph offers a view of the Lewis operations in 1890, eight years before the Pine Grove Pulp Mill burned down. (Lewis County Historical Society.)

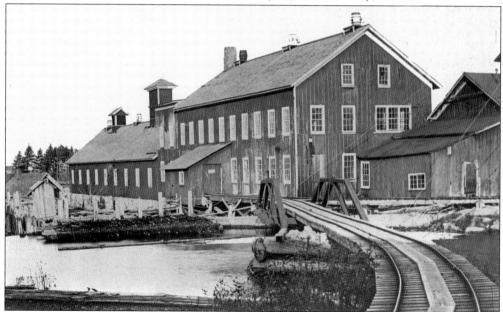

In 1889, J.P. Lewis, with his brothers-in-law John N. Slocum and Martin R. LeFevre, built the first paper mill in Beaver Falls (above) and began manufacturing pulp board and waterproof construction material. Lewis, Slocum, and LeFevre built a second mill in 1892, which had a 64-inch machine to produce carpet paper. In 1903, the company began producing Beaver Board, a fiber board used in panel construction. (Lewis County Historical Society.)

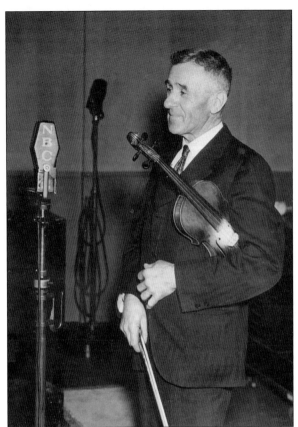

In 1901, George Bardo (1872–1952) purchased his father's Beaver Falls blacksmith shop, and then worked there for decades. As a child, George learned to play the fiddle by ear; in 1912, he helped organize the Beaver Falls Citizens Band. In this 1936 photograph, he is performing at Radio City Music Hall. His blacksmith shop is on permanent display at the Adirondack Museum. (Lewis County Historical Society.)

In 1851, Hiram Lewis's 16-year-old daughter Celestia became the first certified schoolteacher in Beaver Falls. The log cabin in which she taught was replaced in 1857 by a red frame structure. In 1885, the community built the school pictured here. The building had two large rooms on the first floor; enclosed stairways, one for boys and another for girls, led to the second floor. A sliding door that divided the second floor into two rooms could be raised for assemblies. (Larry Myers collection.)

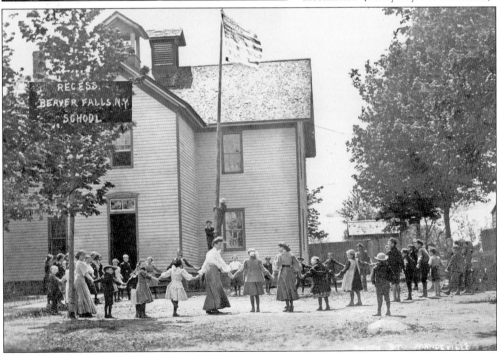

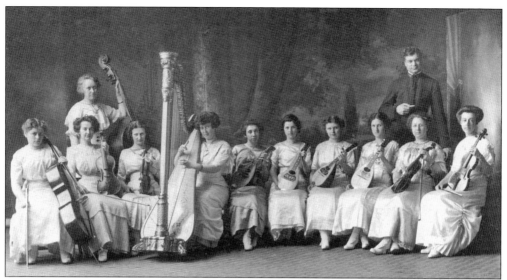

Luther B. Askins (standing at right) was the director of the Ladies String Orchestra of Beaver Falls, an 11-piece group organized in 1912. After studying music in Boston, Askins came to Lowville, where he directed the village band from 1908 until 1932. In 1927, Askins organized the band at Lowville Academy and taught there into the 1950s. His father, Luther B. Askins Sr., was the first African-American to play on an integrated baseball team. (Lowville Free Library.)

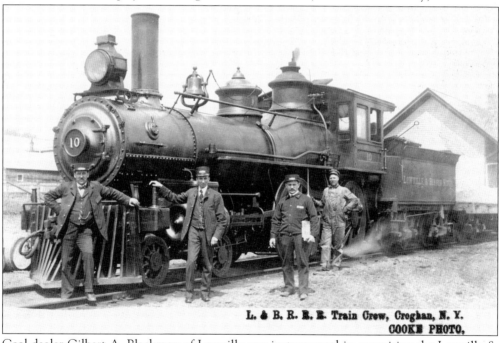

Coal dealer Gilbert A. Blackmon of Lowville was instrumental in organizing the Lowville & Beaver River Railroad. In 1906, this railroad began operating a 10.5-mile line between Croghan and Lowville, with stops at Beaver Falls and New Bremen. In 1916, the railroad purchased a gasoline-powered car to transport passengers. This "jitney" allowed students to commute to Lowville Academy while living at home. The Railway Historical Society of Northern New York now maintains a museum in the Croghan depot. (Lyons Falls History Association.)

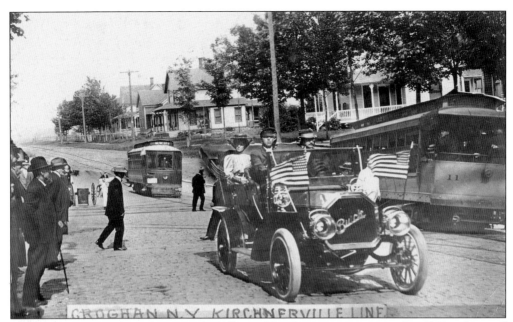

First known as "French Settlement," the Village of Croghan was incorporated in 1841 and named in honor of Lt. Col. George Croghan, who won fame in the War of 1812 for his defense of Fort Stephenson, Ohio. The village is largely in the Town of Croghan but extends into the Town of New Bremen and is the only incorporated village in either township. In this image, photographer Henry M. Beach pokes fun at the rural character of the Croghan area. (George Davis collection.)

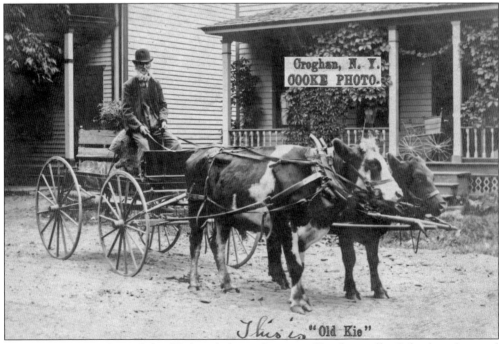

German immigrant Peter Cahe (Kie) settled on a farm near Kirschnerville. Cahe drew firewood for the J.P. Lewis Co. in the late 1890s with his two oxen, Fritz and Mike. When one ox died, he paired the other with a horse. (Lewis County Historical Society.)

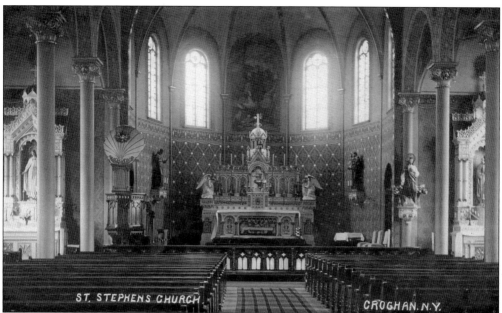

Chancellor Otto von Bismarck of Germany expelled the Franciscan Order from Thuringia in 1876. Some Franciscans found sanctuary in Croghan, where they built St. Stephen's Church, along with a monastery, a convent, and a two-story school. In 1902, fire destroyed a large portion of the village, including all church structures. A new St. Stephen's Church (pictured) opened for worship in autumn of 1903. (Lewis County Historical Society.)

The new St. Stephen's Church measured 125 feet by 65 feet and had a 140-foot-high steeple. The school, monastery, and convent were all rebuilt and just barely escaped the great fire of 1912. (Larry Myers collection.)

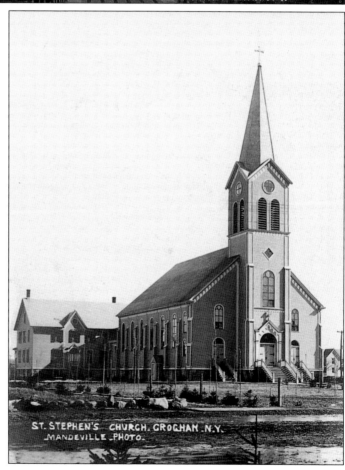

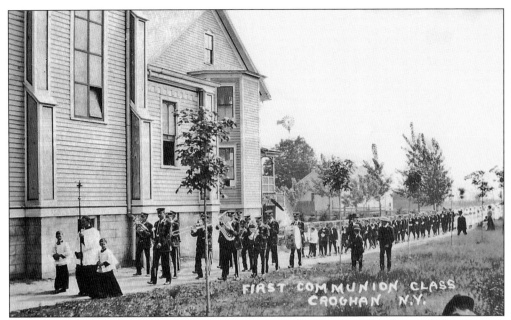

In 1850, approximately two-thirds of the population in the Towns of Croghan and New Bremen was Catholic. In the photograph, altar boys and the Croghan Band lead a procession of children preparing to make their first communion. The procession, with boys in front and girls in back, is moving from the school to St. Stephen's Church. (Larry Myers collection.)

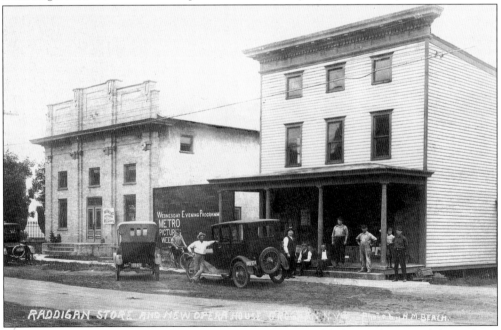

In early 1912, Croghan's Main Street featured a recently remodeled opera house and the Radigan family's new store. But in April of that year, both were lost to a conflagration that swept through town, destroying 34 buildings and doing about $500,000 in damage. The opera house was soon rebuilt (left), as was the Radigan store (right). Edwin H. Radigan continued to run the store until 1931, when the store burned down again; he chose not to rebuild. (Larry Myers collection.)

From about 1880, Augustine Simonet operated a drugstore in Croghan. After losing his store to the fire of 1912, he commissioned Charles L'Huillier to put up a new building (pictured at left). With Simonet's health failing, his wife, Dr. Sarah E. Simonet (1854–1922), began managing the business. Though opposed to women's suffrage, Sarah graduated from Albany School of Pharmacy in 1883, becoming the first woman to do so. In 1885, she received a medical degree from the University of Buffalo. (George Davis collection.)

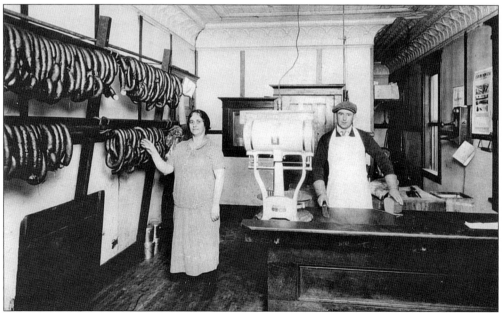

Croghan Bologna, a type of smoked sausage, is celebrated throughout the North Country. Fritz Hunziker (1847–1958) emigrated from Switzerland in 1888 and soon thereafter began producing the specialty meat at his Croghan Meat Market. In this 1927 photograph, Jesse Bush Campany and Elmer Campany are cooling freshly made rings of bologna in the front of their store. (Charmaine and John Campany collection.)

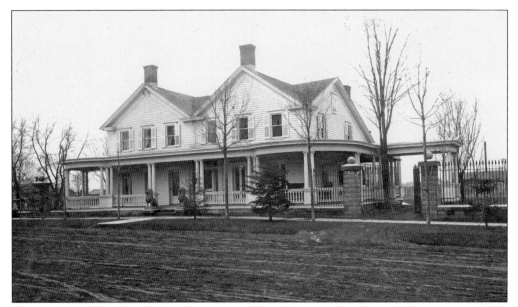

Three-year-old Theodore B. Basselin emigrated from France to Croghan with his parents in 1854. Though he graduated from a Roman Catholic seminary, Basselin chose to enter business. Saving wages earned at his mother's store, Basselin was able to purchase local woodland and eventually accumulated 15,000 acres. In 1877, he began logging, and by 1887 he was operating a sawmill at Forest City. Eminently successful in business, Basselin built a handsome residence on Main Street guarded by two life-size lions. (Lyons Falls History Association.)

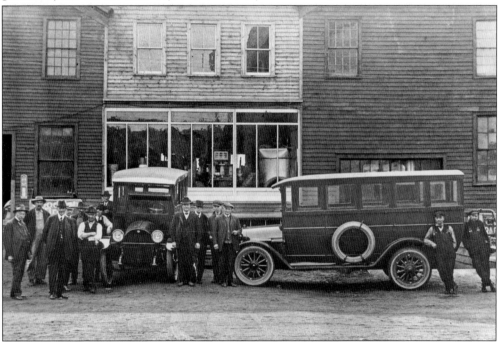

During the 1920s, James D. Zehr operated a bus line between Croghan and Carthage, and in 1930, he began operating a second line between Croghan and Lowville. In this 1924 photograph, Zehr stands next to the hood of the 15-passenger REO bus at right. (Lewis County Historical Society.)

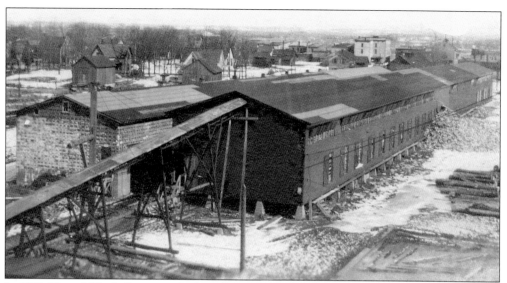

In 1918, United Block Company built a plant in Croghan to manufacture maple blocks, out of which bowling pins and shoe lasts were fashioned. By the 1950s, United Block was turning out 2,000 bowling-pin blocks and 4,000 shoe-last blocks daily. The Croghan plant burned down in 1961 and was not rebuilt, but United Block, a subsidiary of American Machine and Foundry (AMF), continued to operate two plants in Lowville. (Croghan Free Library.)

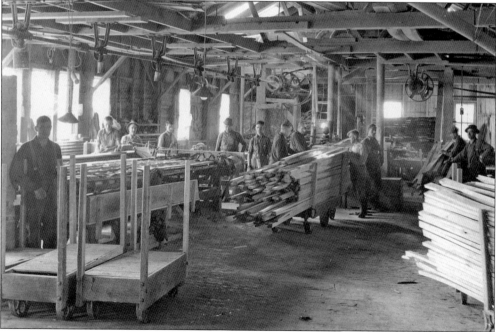

Michael Nortz (1847–1923) ran a general store in Croghan and did extensive lumbering. In 1920, he acquired controlling interest in the Croghan Flooring Mill, located on the south side of Beaver River across from the Lehman and Zehr mill. From the early 1930s to 1946, Elmer English owned and operated the Croghan Flooring Mill, which could turn out 6,000 feet of flooring daily. Maple was the principal hardwood used, but birch and beech were also sawn and milled for flooring. (Croghan Free Library.)

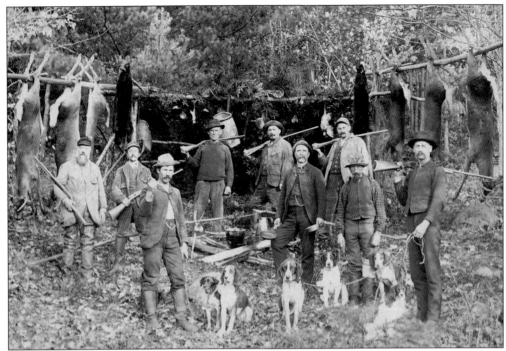

A group of Croghan men pose with their dogs after a successful hunt. In 1897, the state outlawed hounding—the use of dogs to run down deer. At the same time, the state outlawed jacking. "Jacks" were hand-held lanterns that cast a brilliant, directed light. When used in boats, these lanterns would immobilize deer along the shore, turning them into stationary targets. William A. Cooke of Croghan took this photograph. (Lewis County Historical Society.)

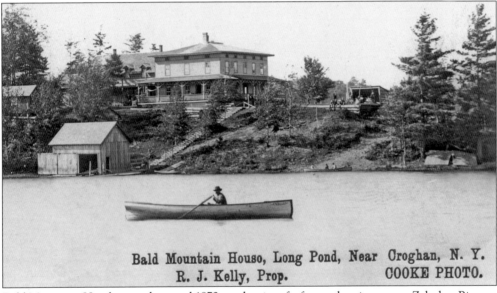

Bald Mountain House, Long Pond, Near Croghan, N. Y.
R. J. Kelly, Prop. COOKE PHOTO.

Bald Mountain Hotel opened around 1872 on the site of a former logging camp. Zebulon Bigness operated the resort during the 1880s, charging $1.50 a day or $7 a week. This photograph was taken sometime around 1903, when Croghan restaurateur Robert J. Kelly began leasing the property from the Long Pond Fish and Game Club. (George Davis collection.)

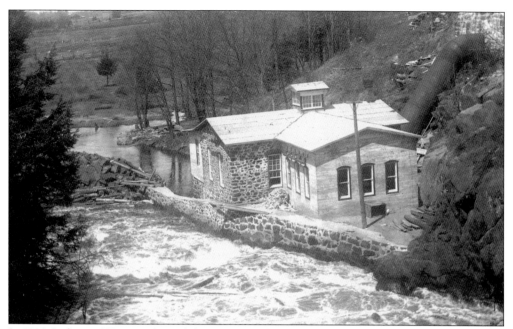

In 1898, Lafayette Wetmore formed the Wetmore Electric Company and built a hydroelectric plant at Belfort on Beaver River. His 400-kilowatt generator supplied electricity to Lowville, which was 14 miles away. Wetmore later installed a second generator to provide electricity to the communities of Croghan, New Bremen, Naumberg, and Castorland. (George Davis collection.)

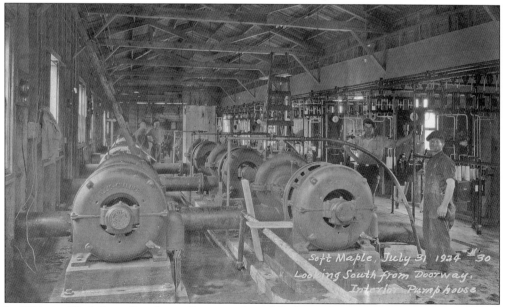

In 1924, the Black River Regulating District enlarged Stillwater Reservoir on Beaver River. At the same time, the Northern New York Utilities Co. erected a power plant 10 miles downstream at the new Soft Maple Reservoir. This plant, which cost $3.5 million, had the capacity to generate 24 million kilowatts hours annually. With the completion of the Moshier Falls project in 1929, there were eight generating stations on Beaver River between Stillwater and Croghan. (Lewis County Historical Society.)

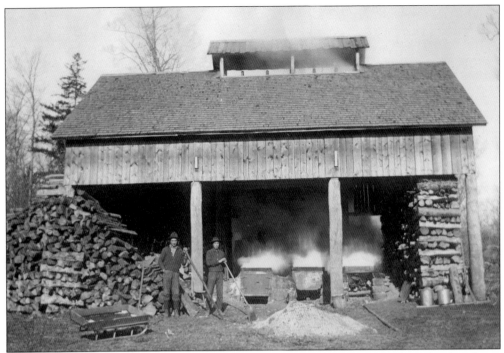

Lewis County in general—and the Croghan area in particular—is renowned for the abundance and excellence of its maple syrup. This 1907 photograph shows the Joseph B. Yousey sugar bush on the Belfort-Soft Maple Road outside Croghan. In 1907, this operation produced 5,600 pounds of maple sugar in addition to a large quantity of maple syrup. At the time, maple sugar retailed in Lowville for 12¢ a pound. (Arlene Yousey collection.)

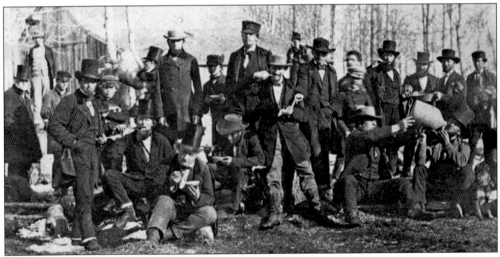

This photograph, taken by E.M. Van Aken in 1861, depicts a sugaring-off party at the Lowville farm of Charles M. Stephens. Dr. Franklin B. Hough, often called the "Father of American Forestry," is sitting second from the left. In 1874, Hough was instrumental in establishing a Division of Forestry within the US Department of Agriculture. Artifacts associated with the production of maple syrup in Northern New York are on permanent display at the American Maple Museum in Croghan. (Lewis County Historical Society.)

Two

DAIRY FARMING AND CHEESE MAKING

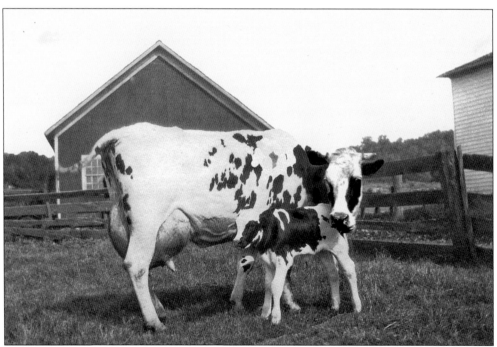

By the 1840s, dairy farming was well established in Lewis County. After the Civil War, local farmers began raising graded cattle, notably Holsteins but also Jerseys, Guernseys, Brown Swiss, and Ayrshire. This 1925 photograph shows a prized milch cow and her calf on Philip Moser's Kirschnerville farm. The Moser homestead, now more than 150 years old, is maintained as the Adirondack Mennonite Heritage Farm and is open to the public. (Arlene Yousey collection.)

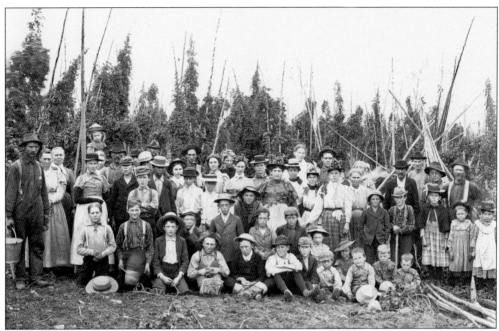

In the years following the Civil War, hops became an important agricultural commodity in Lewis County, especially in the Harrisburg area. Some hops were used locally at breweries in Croghan, Lowville, and Constableville, but most were shipped to Rome and Utica, where they fetched between 10¢ and 12¢ a pound in 1895. In this image, a large group of workers has gathered to harvest the hops, which grow on 20-foot-long vines. (Lewis County Historical Society.)

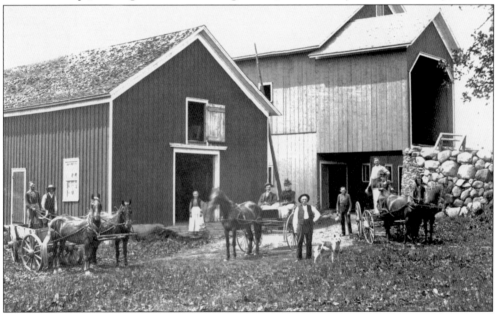

Around 1860, veterinarian Dr. William Wendt built these barns on his Crofoot Hill farm outside Constableville. The large, two-story bank (or basement) barn on the right reflects a new style that was becoming popular. The bottom floor was used to house livestock, while the upper floor served as a hayloft and storage area for farm equipment. (Thomas Stocklosa collection.)

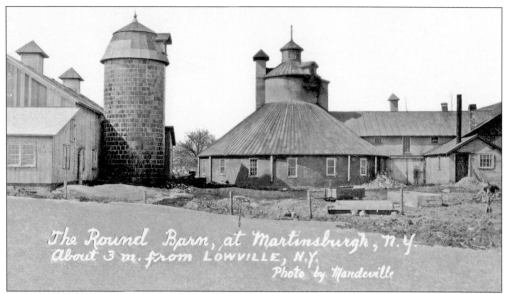

In 1909, Dr. M. Anstice Harris of Elmira College aroused considerable curiosity when she built a round barn in Martinsburg, intending to sell certified raw milk to New York City customers at a premium price. The barn had a concrete floor and stanchions arranged so that each cow faced toward the center. Every day, 20 men in white uniforms bathed and groomed a herd of 100 cows. The enterprise declared bankruptcy in 1918. (Larry Myers collection.)

John Allis and the Fowler Brothers patented an apparatus for watering stock in their stalls. The device was available at Allis and Fowler's Hardware Store in Lowville. Pictured in this 1890 photograph are, from left to right, Philip S. Fowler, Elyah Hubbard, L.D. Fowler, Lincoln Larabee, and Clint Larabee. (Lewis County Historical Society.)

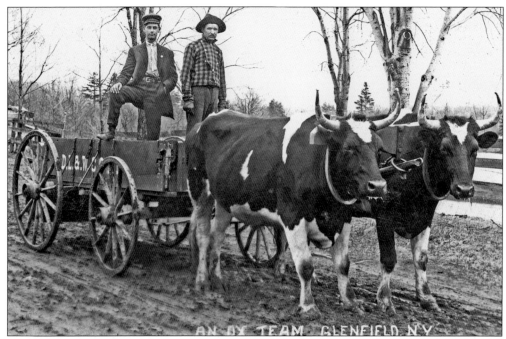

The pioneer farmers of Lewis County relied on oxen to clear and plow the land. Early woodsmen used the animals to skid trees, but by the 1850s, commercial loggers generally preferred horses. Lafayette Wetmore, however, continued to use oxen for logging at his Maple Ridge operations well into the 1890s. This photograph features one of Wetmore's three teams. (George Davis collection.)

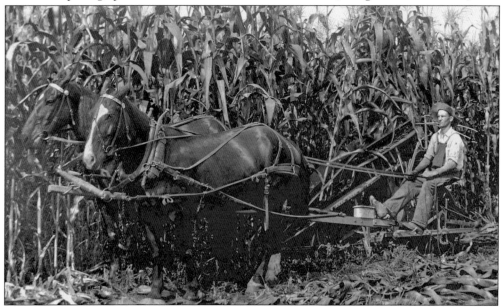

Joseph Ebersole harvests 15-foot-high corn on his Beaver Falls farm. By the 1890s, ensilage—the storage of green fodder for later use—was becoming widespread. When grain is tightly packed in a silo, oxidation and fermentation are limited, preserving the taste and nutritional value of the food. Before ensilage became popular, dairy farmers often avoided the cost of wintering their cows by selling them in the fall and buying a new herd in the spring. (Larry Myers collection.)

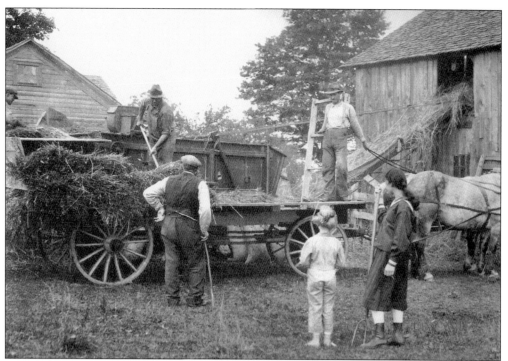

In the 1860s, farmers began using horse-drawn mechanical mowers to cut hay, which was then raked and stacked to dry. Automatic twine balers began to appear shortly before World War II. In the photograph, a farmer near Talcottville transfers hay from a wagon to a loader. (Thomas Stocklosa collection.)

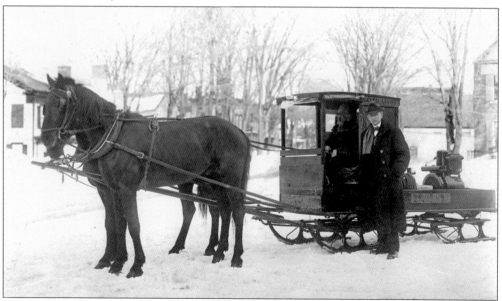

Despite the abundant water power in Lewis County, many farmers remained off the electrical grid until well into the 20th century. To meet their needs for electricity, some farmers turned to portable generators. In 1909, Delco founder Charles F. Kettering marketed a line of single-cylinder engines powered by kerosene and cooled by air. This photograph dates from 1915. (Author's collection.)

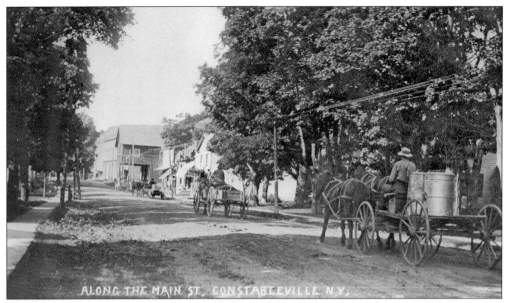

A farmer draws a bulk container of milk through the streets of Constableville. (Larry Myers collection.)

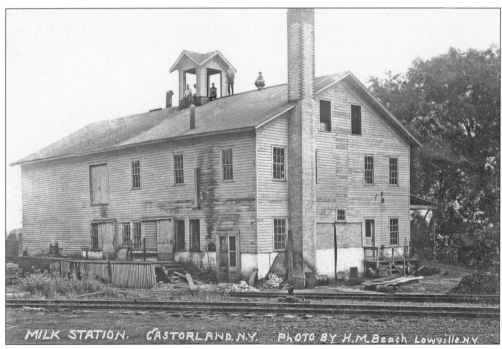

In 1899, the Five States Milk Producers' Association organized to regulate the amount of milk being shipped to New York City. The association had local branches in Lowville, Castorland, East Martinsburg, Glenfield, and Leyden, but it had limited success in securing a fair price for fluid milk. In 1913, dissatisfied dairymen in the Castorland area formed the Central Dairy Company and converted John Elsaser's hassock factory into this milk plant. (Larry Myers collection.)

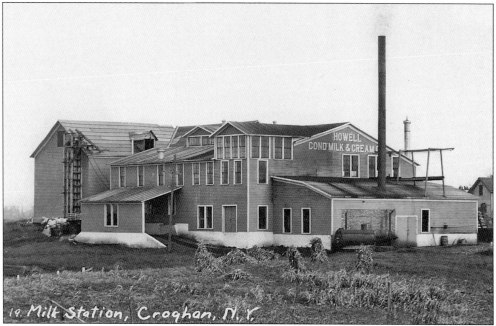

James A. Howell of Goshen owned the Howell Condensed Milk and Cream Company, which had milk stations throughout the state, including this one in Croghan. In 1916, he sold his company to Borden for $250,000. During the Civil War, Gail Borden of Norwich made his fortune selling condensed milk to the Union army. Condensed milk became popular because it had a long shelf life and was free of the pathogens sometimes found in raw milk. (Larry Myers collection.)

By 1880, cheese making had become an important industry in Lewis County. In his *Lewis County Business Directory for 1895*, William Adams lists 93 commercial operations—11 in the Town of Martinsburg alone. One of the best known plants was that of Frank C. Gowdy, who owned and operated the West Martinsburg Cheese Factory. (Loretta Alexander collection.)

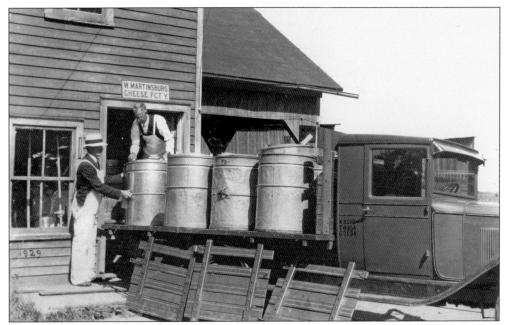

After World War I, the Gowdy factory in West Martinsburg produced both hard and soft cheeses. This image shows milk delivery to the factory in 1929. Wesley Alexander purchased the factory in 1925 and continued to operate it for almost 30 years, specializing in kosher cheese for the New York market. (William H. Bush Memorial Library.)

Making cheese in the traditional manner did not require complex equipment, but the results were not always predictable. The willingness of cheesemakers to adopt new techniques in the late 19th century led to a more consistent product. The availability of rennet extract in the 1880s and the introduction of reliable tests for butterfat content and acidity in the 1890s helped enhance the reputation of New York State cheese. (Loretta Alexander collection.)

During the 1880s, the John S. Martin Cheese Company cultivated a market for New York State cheese on the West Coast. Sometime after Martin's death in 1904, R.J. Richardson and L.S. Miller acquired control of the company. In 1915, John S. Martin Cheese Company of Lowville won a gold medal for its Rabbit Brand Cheese at the Panama Pacific International Exposition. The Adirondack Maple Syrup and Sugar Company of Lowville also received a gold medal at the exposition. (Lewis County Historical Society.)

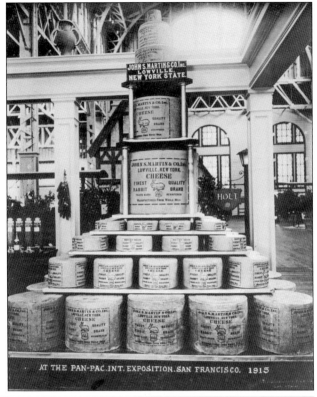

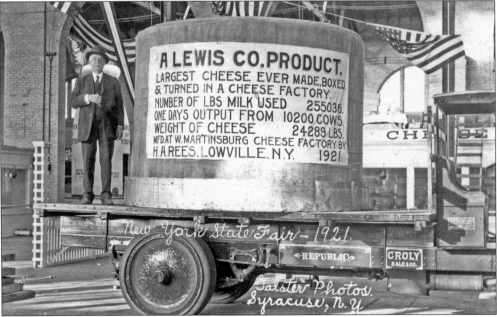

Horace A. Rees (pictured above), an agent with the New York State Agriculture Department, supervised the manufacture of a 12-ton big cheese at the West Martinsburg Cheese Factory. The cheese was displayed at the New York State Fair in 1921. Other big cheeses were produced for display between 1908 and 1938. (Larry Myers collection.)

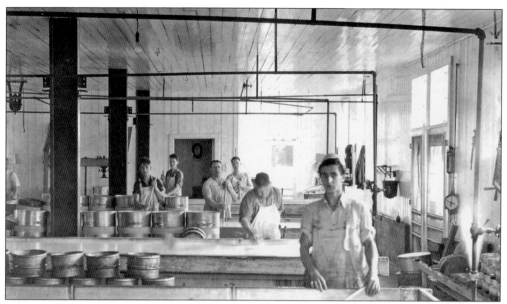

Around 1900, Frank Hoffman of Lowville began to manufacture cheddar cheese. His son Valentine took over the business in 1922 and formed a partnership with Dwight N. Dudo in 1938. Hoffman and Dudo made cheeses for exhibition well into the 1950s at their factory near the Illingworth Bridge on Black River. This photograph was taken at a Hoffman and Dudo's cheese factory in Croghan. (Lewis County Historical Society.)

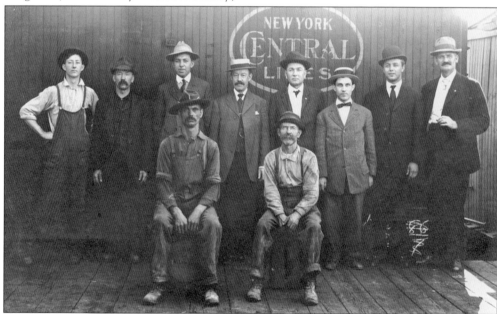

In 1899, the New York Central began transporting milk in refrigerator cars. New York Central Train No. 64 departed Carthage daily for Utica with about 10 milk cars. Each car held about 300 forty-quart milk cans, which were cooled by ice placed either on top of the cans or at the ends of each car. Trains were scheduled to arrive at the 60th Street milk yard in Manhattanville between 11:30 p.m. and 3:30 a.m. This photograph shows New York Central personnel in Lowville. (Larry Myers collection.)

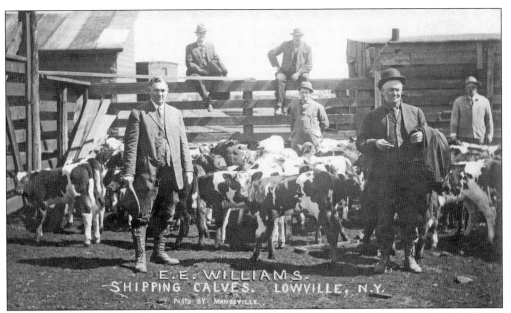

Between April and November, farmers hauled their milk to collection stations and local cheese factories, but during the winter, many farmers used their milk to fatten calves for the veal market. During that period, itinerant livestock dealers would visit area farms to contract for the sale and delivery of calves at a local stockyard. One such dealer was Edward E. Williams of Lowville (left), who ran special cattle trains. (Lewis County Historical Society.)

In 1899, Brayton B. Miller and his son Leon S. established the Lowville Milk and Cream Company (pictured above). Two years later, brothers Rufus J. and S. Brown Richardson acquired half-interest in the company. Kraft-Phenix Cheese Company purchased the Miller-Richardson operation in 1928, including the Lowville Cold Storage Plant, which was capable of storing seven million pounds of cheese and was said to be the largest cheese storage facility in the world. (Lewis County Historical Society.)

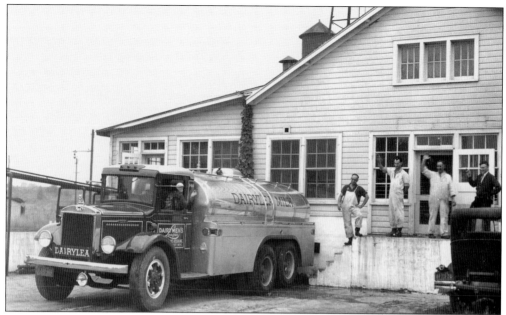

Lewis County Dairymen's League formed in 1918. This organization was a regional association composed of Northeastern farmers who wished to secure a fair market price for their fluid milk. Beginning in 1923, the Dairymen's League began marketing its products under the brand name Dairylea. A second association, Lowville Producers Dairy Cooperative, organized in 1936 as a locally owned and controlled stock company. (Lewis County Historical Society.)

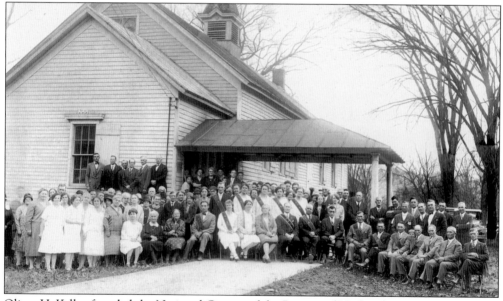

Oliver H. Kelley founded the National Grange of the Patrons of Husbandry in 1867 to promote the general welfare of farmers. In addition to lobbying for better roads, rural free delivery, and agriculture courses in public schools, the Grange was instrumental in establishing the Farm Bureau and the Home Bureau. Lowville Grange 71, pictured on October 26, 1929, organized in 1874 but remained fairly inactive until 1912, when it purchased the Rural Street schoolhouse as a meeting hall. (Lewis County Historical Society.)

Three

NORTHWEST LEWIS

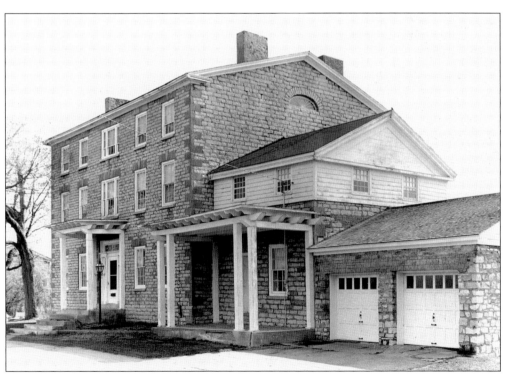

Jesse Blodgett (1764–1848) was one of the first settlers in the Town of Denmark. In 1800, the year of his arrival, rich farmland in the area was selling for between $2 and $3 an acre. Preferring hostelry to agriculture, Blodgett opened a wood-frame tavern in 1812. After that structure burned down, he replaced it with a more durable limestone building (pictured) in 1824. Blodgett rented the third floor to the Freemasons. (Lewis County Historical Society.)

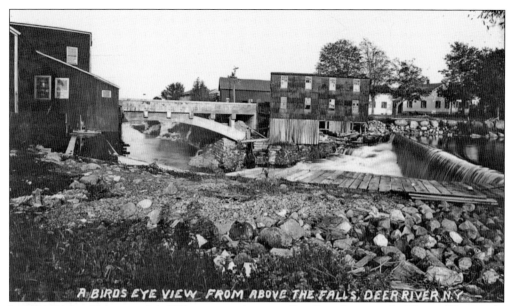

In 1824, Richard Myers and A. Wilson erected a sawmill at Deer River in the Town of Denmark. Operated by Otho A. Lanphear during the 1870s and 1880s, this mill produced rakes, broom handles, and shade rolls in huge quantities. (Larry Myers collection.)

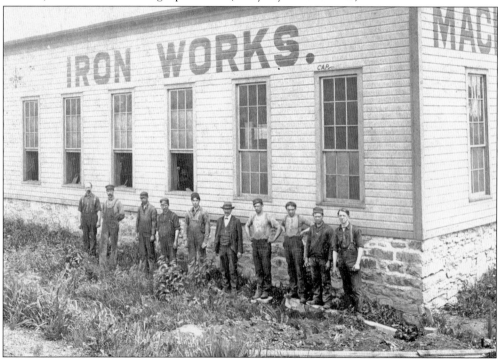

Deer River's best-known product was Thomas L. Kidney's Deer River Plow. After Kidney's untimely death in 1883, Drs. Alexander R. Gebbie and H.D. Bingle acquired the firm and continued to manufacture the plow. Around 1900, Dr. Gebbie and Lafayette Wetmore took over manufacture of the plow at their recently acquired Lowville Iron Works (pictured). (Lewis County Historical Society.)

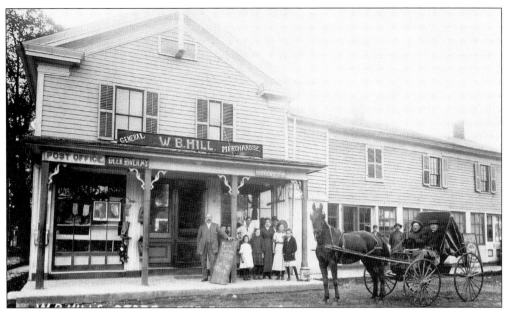

E.L. Hulbert opened this general store in 1848 and maintained it until 1881, when E.D. Mix took over. From 1884 to 1944, father and son Wallace R. and Wallace B. Hill ran the store. During their tenure, the store not only did duty as the Deer River Post Office but provided telegraph and telephone service to the community. Lewis Miller acquired the store in 1945, and Leon Rohr bought it in 1952. Fire destroyed the building in 1958. (Fred Snyder collection.)

In 1801, Nathan Munger built a sawmill and, two years later, a gristmill near High Falls, just east of Copenhagen, Town of Denmark. Here, Deer River flows over a bench of Trenton limestone and plunges 166 feet into a forbidding gorge as it makes its way eastward to Black River. The Deer River Power Corporation organized in 1909 and built a 30-foot concrete dam above the falls. This E.M. Van Aken photograph dates from the 1860s. (Lewis County Historical Society.)

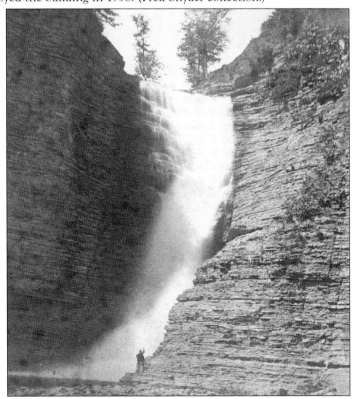

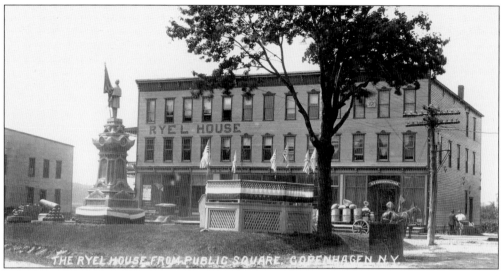

In 1807, residents of Munger's Mills changed the name of their settlement to Copenhagen to protest the British siege of Denmark. At the heart of Copenhagen is the Village Park, flanked on the west by Brooks House (later known as Ryel House). The park acquired a soldiers' memorial in 1893, a 2,500-pound siege howitzer in 1897, and a new bandstand in 1910. (Lyons Falls History Association.)

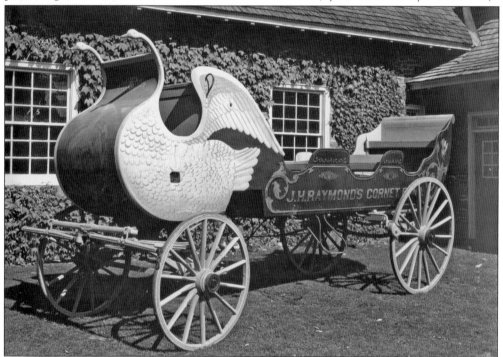

The Copenhagen Band, established in 1843, was the first community band in the state. Under the tutelage of George J. Hazen, John H. Raymond, and C. Leon Ryel, numerous musicians from Copenhagen went on to perform in orchestras, circuses, and traveling shows. Local blacksmith Mert Corcoran built the $500 bandwagon pictured above, and Joseph Wolff did the lettering. The wagon, capable of seating 18 musicians, is on permanent display in the Copenhagen business district. (Lewis County Historical Society.)

During the Civil War, John H. Raymond (1839–1912) served as a musician in the regimental band of the 35th New York Volunteers. On returning to Copenhagen, he opened a pharmacy and assumed the position of local bandmaster, replacing Sanford Hunt, who had been appointed to direct the US Marine Corps Band in Washington, DC. In the late 1870s, the J.H. Raymond Cornet Band wore blue swallowtail coats decorated with brass buttons and red piping. The hats were black plush silk and each sported a red ostrich feather. (Lewis County Historical Society.)

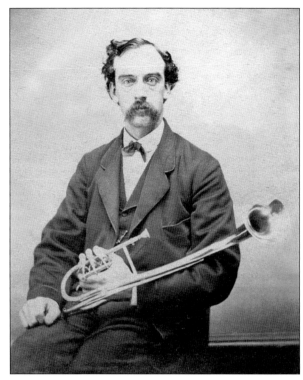

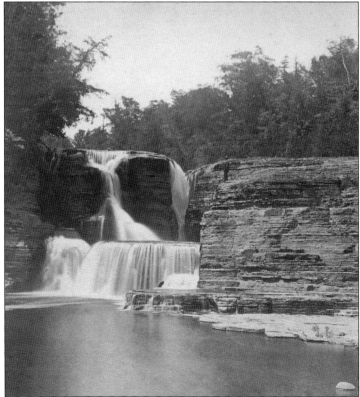

At King's Falls, about three miles downstream from High Falls, Deer River drops 40 feet on its way to Black River. This waterfall is said to have been named by Joseph Bonaparte, former king of Naples and Spain, who settled at nearby Natural Bridge after his brother's defeat at Waterloo. E.M. Van Aken of Lowville took this photograph. (Lewis County Historical Society.)

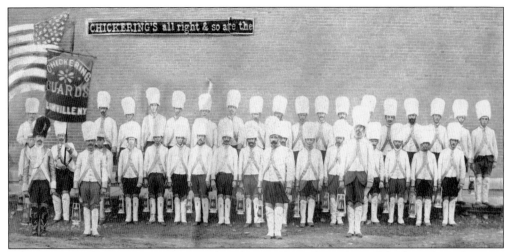

In the decades following the Civil War, political parties formed marching clubs throughout the state. Accompanied by local bands, these clubs held torchlight parades to generate enthusiasm for their candidates. In 1880, Lewis County Republicans formed the Chickering Guards, named for Charles A. Chickering (1843–1900) of Copenhagen, who served in the US House of Representatives from 1893 to 1900. This photograph dates from 1896, when the Chickering Guards were campaigning for presidential candidate William McKinley. (Lowville Free Library.)

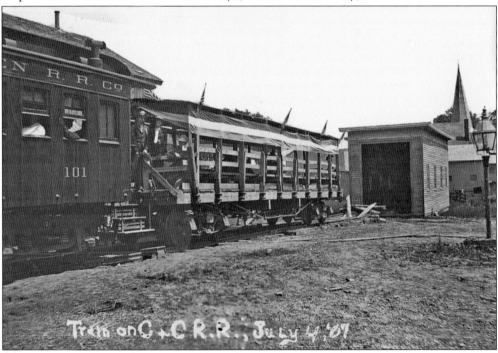

Perennially frustrated by the lack of rail service, residents in the Town of Denmark raised $10,000 to build a rail line between Copenhagen and Carthage. The new route opened on June 28, 1907, but with customers able to flag down and board passing trains, service proved somewhat erratic. Within a decade, the Carthage & Copenhagen Railroad was forced to reorganize, becoming the Deer River Railroad Company. Operations ceased in 1918. In this photograph, an open-air passenger car has been added for a Fourth of July excursion. (Larry Myers collection.)

Peppermint, grown for its essential oil, was once cultivated in the Harrisburg area. Another historically important crop, hemp (*Cannabis sativa*), was grown around Copenhagen, where Abraham Varick established a rope walk in 1832. To supply his factory with raw material, Varick encouraged local farmers to plant hundreds of acres of hemp. Separating the fibers of the plant proved difficult, however, and the factory struggled financially for decades. In the photograph, a Copenhagen youth is perched on a horse-drawn hay rake. (Lewis County Historical Society.)

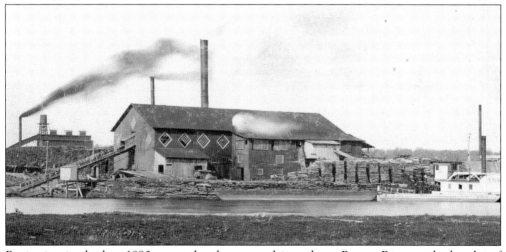

Beginning in the late 1880s, countless logs were driven down Beaver River to the hamlet of Castorland on the west bank of Black River. With access to both canal and rail service, Castorland became an important shipping center for lumber and forest products. In 1883, Theodore Basselin (1851–1914) built a large sawmill at Castorland. His beloved steamboat, the *T.B. Basselin*, is visible at far right. (Lewis County Historical Society.)

Theodore Basselin's mill, with five 100-horsepower Corliss steam engines and gang saws, ran continuously, producing 200,000 feet of lumber over the course of a 24-hour day. After Andrew Shanz's adjacent planing mill burned in 1888 and Timmerman Brothers' nearby kindling-wood factory burned in 1889, Basselin purchased the properties, rebuilt the businesses, and ran them as his own. (Lewis County Historical Society.)

In 1898, George E. Hufcut commissioned his son-in-law Burton G. Buxton to erect this frame structure in Castorland. Hufcut opened a general store here, selling fancy coffee for 10¢ a pound and granulated sugar for $5.30 a hundredweight. The store burned in 1913, but Hufcut rebuilt it and remained in business until 1917. Soon thereafter he conveyed the store to Wesley J. Snyder, who ran it until 1956. Displayed in the window is a campaign poster for presidential candidate William Jennings Bryan. (Ed Yancey collection.)

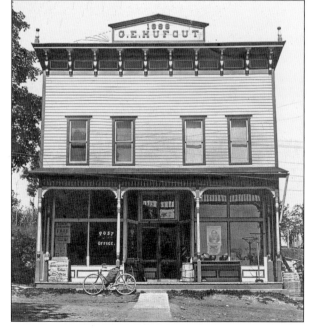

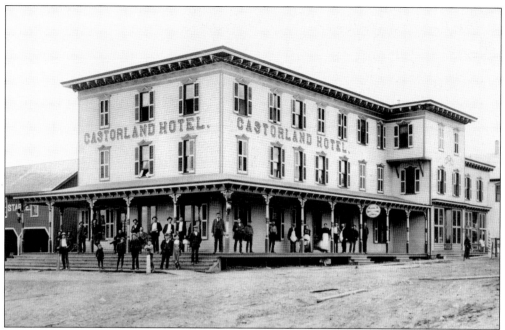

In 1896, Henry Wetmore erected the three-story Castorland Hotel at the corner of Main and Railroad Streets. Fire destroyed the structure in 1904, along with the village post office, Brown and Berry's meat market, Fred Parquet's barbershop, and Jesse Ellis' harness shop. (Lewis County Historical Society.)

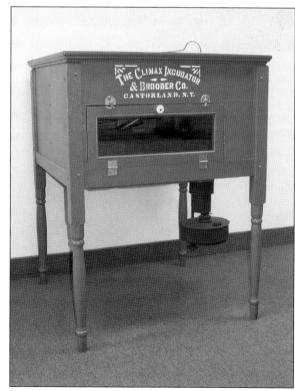

In 1902, Samuel L. Hirschey (1874–1918) patented the Climax Chicken-Brooder. This apparatus prevented fumes from mingling with the heated air inside the chamber. By 1904, the brooder was being produced in large quantities at Castorland, but Climax sold the patent to concentrate on the manufacture of cardboard boxes and packaging material. (Author's collection.)

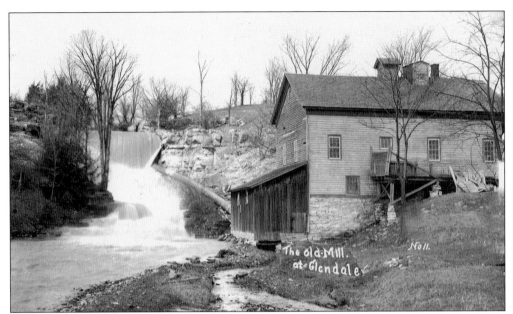

Whetstone Creek, which runs through the hamlet of Glendale, powered William Jones's flour and feed mill (pictured). The hamlet, though never large, began to decline with the arrival of the Utica & Black River Railroad in 1868. The railroad placed Glendale Station nearly a mile east of Glendale, prompting a new community, Glenfield, to form around the depot. (Arnold Weber collection.)

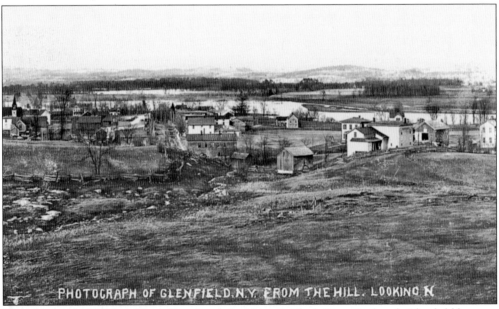

Served by both the Black River Canal and the Utica & Black River Railroad, Glenfield became the most populous community in the Town of Martinsburg. Between 1902 and 1932, Glenfield & Western Railroad brought in timber from Tug Hill, and very briefly, the Glenfield & Eastern Railroad delivered timber from the Brantingham area. The view in this H.M. Beach photograph is from the lower slope of Tug Hill looking north and east across Black River toward the Adirondacks. (Larry Myers collection.)

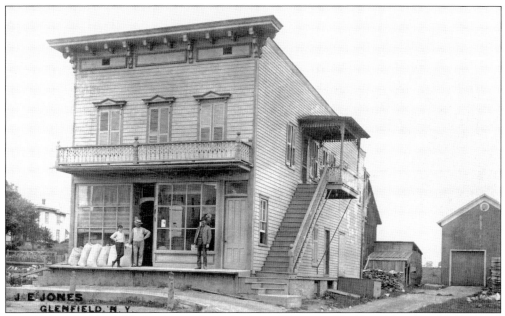

James D. Smith, Glenfield's first lawyer, built the Oscar Wormwood Building (above) and maintained an office in part of it. Shortly after 1890, J. Emery Jones ran a feed store in the building in connection with his father William R. Jones's mill in Glendale. In 1901, the Glenfield & Western Railroad began using the bottom floor of the Wormwood Building as its depot. Jones moved his store across the street, where he conducted business until 1911, when he built a new gristmill on nearby Black River. (George Davis collection.)

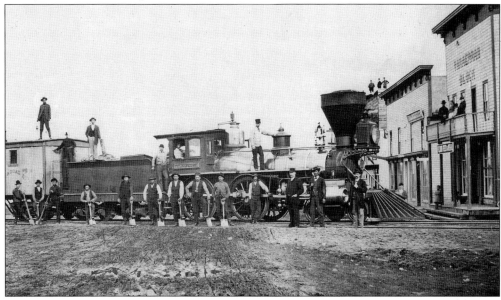

The Utica & Black River Railroad extended its tracks northward from Boonville to Lowville in 1868 and as far as Carthage in 1871. The line was leased to the Rome, Watertown, & Ogdensburg Railroad in 1886 and to the New York Central in 1891. In this image, the *Thomas Foster*, a wood-burning engine built by the Schenectady Locomotive Works in 1872, is stationed in front of John Van Aernam's General Store in Glenfield. (Lewis County Historical Society.)

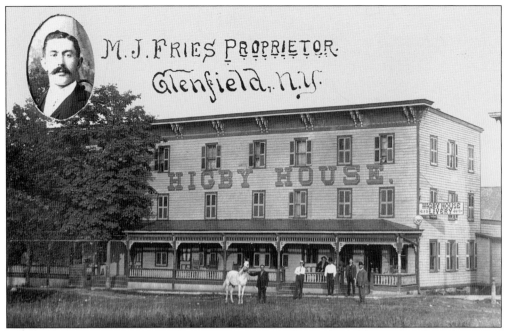

Anticipating the arrival of the railroad, Harris S. Higby built Glenfield's first hotel, Higby House, in 1868. In 1895, Alsatian immigrant Michael Fries purchased the property and ran the hotel until 1929, when it burned down. Around 1883, Ira Foote erected Phillips House, Glenfield's second hotel. (Lewis County Historical Society.)

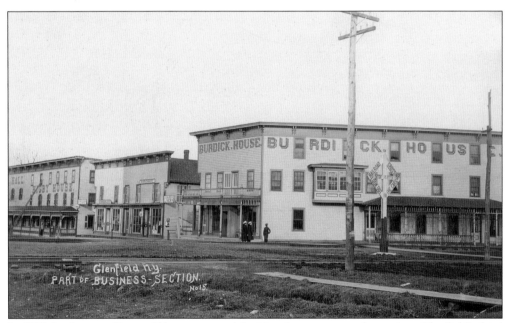

In 1898, lumberman Henry Abbey converted the Van Aernam general store into Glenfield's third hotel. Franklin G. Burdick later purchased this hotel and ran it as Burdick House until 1906, when he sold it to James D. Smith, who ran it as the Central Hotel. (Larry Myers collection.)

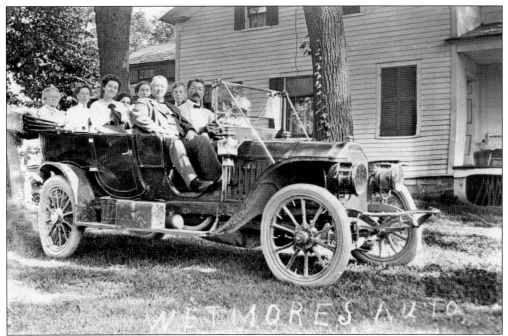

In 1888, G.H.P. Gould, Samuel Garmon, and Alexander Crosby built the Fulton Chain Railroad, whose locomotive ran on wooden rails between Moose River Settlement and Minnehaha. To cut the rails, contractors employed a portable sawmill that Lafayette Wetmore (1857–1910) had devised. As the railroad was being built, Wetmore purchased large tracts of forestland at the end of Maple Ridge Road in the Town of Martinsburg, where he established the small mill town of Wetmore. (George Davis collection.)

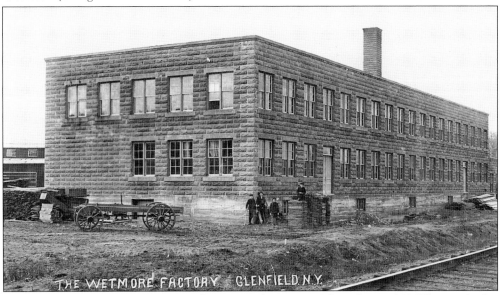

Lafayette Wetmore acquired the Lowville Iron Works in 1898. After a fire in 1902, Wetmore built a new factory near the Lowville rail yard, which he sold several years later to the Fulton Machine and Vise Company. In 1907, Wetmore organized the Glenfield Manufacturing Co. (pictured) and soon had a flourishing business producing folding tables from local hardwood. (Larry Myers collection.)

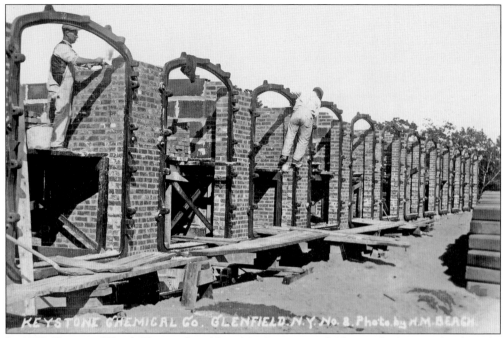

In 1927, Keystone Wood Chemical and Lumber Company of Olean, which specialized in the distillation of chemicals from wood, decided to establish a large plant in Glenfield. Keystone purchased 20,000 acres of Monteola Hardwood Company's forestland on Tug Hill and acquired stumpage rights to 100,000 acres in the Mary C. Fisher Tract east of Brantingham Lake. Along with a new sawmill, steam plant, and powerhouse, Keystone built kilns, distillation facilities, retorts, coolers, and shipping docks. (George Davis collection.)

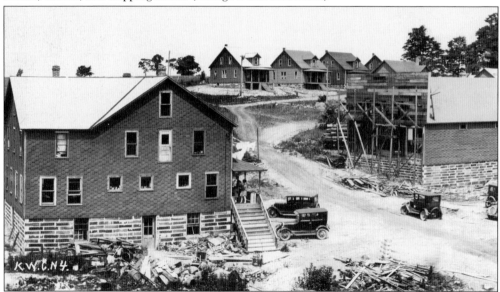

Capitalized at $3 million in 1927, Keystone promised a bright economic future for the Glenfield area. To provide housing for its workers, Keystone dismantled 40 buildings at its plants in Pennsylvania and reassembled them in Glenfield. The cottages, along with a company store and boardinghouse, were known as "Pennsy Lane." (Lewis County Historical Society.)

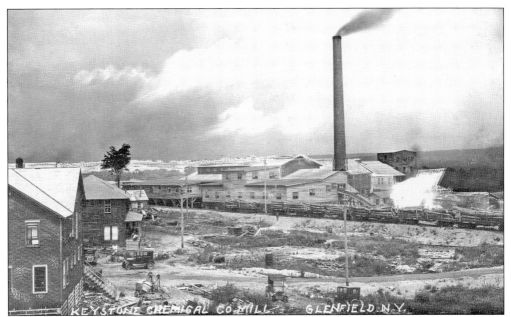

For two years, the Keystone Chemical Company seemed to find a ready market for its acetate, ether, methyl alcohol, dyes, and charcoal. But the company was financially overextended and went bankrupt in the spring of 1929, just months before the stock market crash. Glenfield's misfortune intensified in August 1929, when a conflagration devastated a large portion of the business district. (Lyons Falls History Association.)

From Big Otter Lake, Otter Creek flows westward through the Town of Greig and enters Black River just north of Glenfield. Today, Otter Creek is known as a quiet Adirondack trout stream, but it once supported a number of industries. These included sawmills at the hamlets of Otter Creek, Dolgeville, Eatonville, Nortonville, and Partridgeville, as well as a tannery (operated by Henry and George Botchford from 1867 to 1899) and a power plant built by Lafayette Wetmore in 1907. (George Davis collection.)

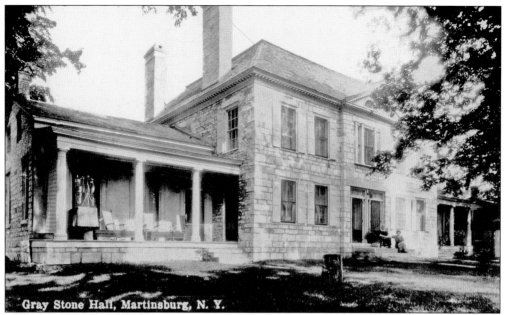

Gray Stone Hall, Martinsburg, N. Y.

Martinsburg is named for Gen. Walter Martin (1766–1834), early settler and commanding officer of the Lewis County Militia. General Martin completed construction of Greystone Hall (pictured) in 1805. His sons John and David added the wings shortly after their father's death. During World War I, Greystone Hall served as a convalescent home for Canadian soldiers, housing 12 at a time. (Larry Myers collection.)

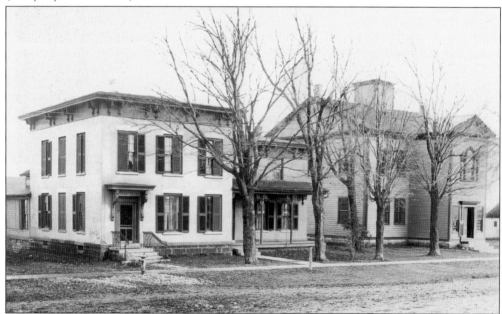

Martinsburg served as the county seat from 1805 (two years after the Town of Martinsburg was formed) until 1864, when Lowville became the county seat. Built around 1812 and largely funded by Gen. Walter Martin, the structure at right—now known as Town Hall—was the first county courthouse. The building at left was erected in 1833 and housed Lewis County Bank. This bank was the first in the county and remained a going concern until 1854. (Lowville Free Library.)

In 1807, Gen. Walter Martin built
the first paper mill in Lewis County.
Located on Roaring Brook, the
mill ground rags into a fine pulp
that was then hand-pressed, sheet
by sheet, in wire-mesh trays. Under
the management of John Clark and
Co., the mill continued to produce
writing paper for 25 years. This stone
bridge is just south of the village
on Roaring Brook and was built by
Daniel Whitaker at his own expense.
(Lyons Falls History Association.)

In 1881, Thomas L. Taylor introduced
the 5¢ "Speckled Trout" cigar at
Havana Cigar Factory No. 1016.
Located in the basement of a brick
block north of Greystone Manor, the
factory was run by various members
of the Taylor family until 1906,
when Clement F. Pitcher and Lewis
C. Lomber purchased it. Vincent
Jarecki, an Austrian émigré of
Polish extraction, later maintained
a store in the building. (William
H. Bush Memorial Library.)

Martinsburg native Walter Bliss Hunt (1796–1859) was a prolific inventor. While living in Lowville, he devised a machine for spinning flax and hemp. His many inventions include the sewing machine, safety pin, fountain pen, and paper shirt-collar, as well as a breech-loading repeating gun, an anthracite-burning stove, and a machine for manufacturing nails. In 1846, he invented an "Antipodean Apparatus" that allowed persons to walk on the ceiling. (Smithsonian Institution.)

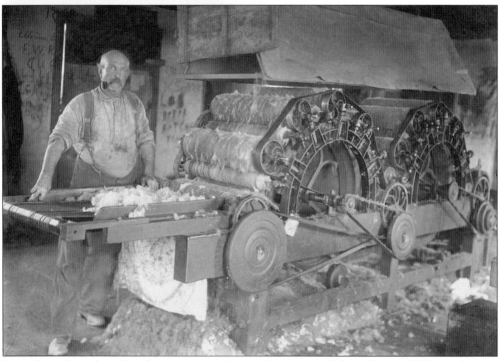

From the earliest days of settlement, Lewis County farmers raised sheep for wool. The production of wool peaked around 1845, when the county boasted 41,000 sheep and a human population of about 20,000. In 1902, Dealton H. Rima (pictured) purchased the Martinsburg Wool Carding Mill from Gilbert Collins, who had inherited it from Reuben Crosby in 1885. In 1904, Rima also began running a hardware store in Martinsburg, and between 1906 and 1920, he operated a sawmill that manufactured cheese boxes. (William H. Bush Memorial Library.)

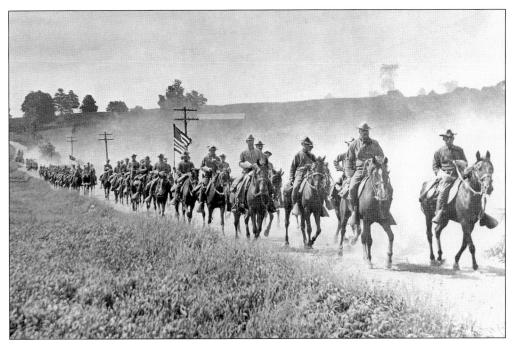

In 1908, the US Army established Pine Camp Military Reservation near the hamlet of Great Bend in Jefferson County. Pine Camp was associated with Madison Barracks at Sackets Harbor and served as a summer training ground for Army regulars and state militia located in the Northeast. For several years, it was common to see cavalry crossing Tug Hill along State Route 12. Troops occasionally bivouacked at the Lewis County Fairgrounds in Lowville. (Lewis County Historical Society.)

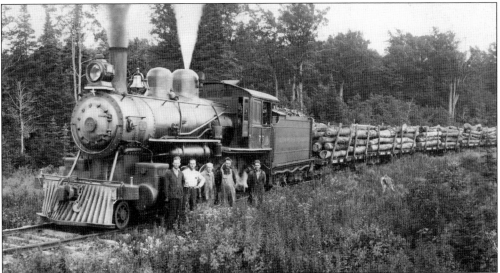

In 1901, Page and Fairchild Co., in conjunction with Dexter Sulphite Pulp and Paper Co., began constructing the 35-mile-long Glenfield & Western Railroad to transport logs from their forests on Tug Hill to their mills at Glenfield. The Glenfield & Western ascended the steep eastern slope of Tug Hill, climbing from Glenfield to various logging locations in the towns of Montague, Highmarket, and Osceola. (Larry Myers collection.)

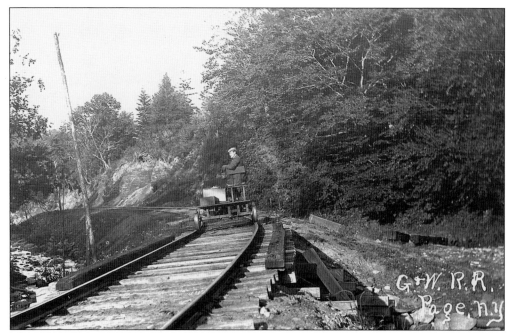

The Glenfield & Western Railroad had steeper grades and more curves than any other railroad in New York. To meet the challenge, the railroad purchased a geared-drive Heisler. With a slanted V-2 engine and all-wheel drive, the engine had good traction on steep grades. This photograph shows a Ford Model T converted into a so-called "jitney." (Lewis County Historical Society.)

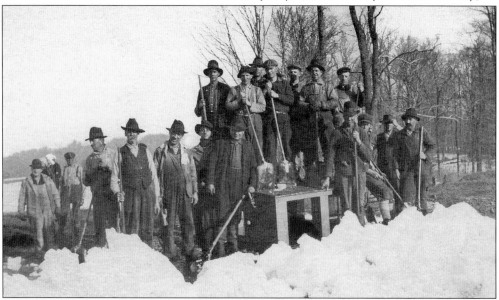

Tug Hill is famous for the heavy snowfall that occurs when warm, moist air sweeps in from Lake Ontario and collides with the colder, drier upland air. Snowfall in the Tug Hill townships averages 230 inches per year. The hamlet of Hooker, however, has recorded 467 inches over the course of a winter, and Montague recently received 77 inches in a single 24-hour period. In the photograph, a crew prepares to shovel out a snowplow on the Glenfield & Western Railroad. (Lyons Falls History Association.)

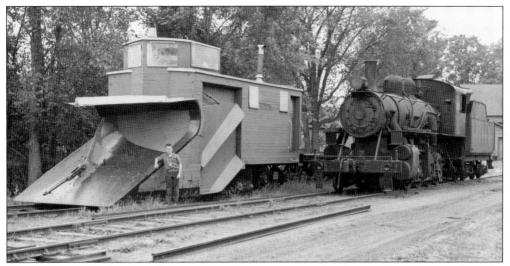

Founded in 1889, the Russell Snow Plow Company specialized in producing snow plows for railroads. Manufactured first of wood and later of steel, these heavy wedge plows were pushed by a locomotive, which moved at a fairly high speed to sustain momentum. A spotter familiar with the route watched for problem areas, such as crossings, where the plow had to be raised to avoid damage. The snowplow above was photographed in 1923 beside Glenfield & Western Engine No. 75. (Lewis County Historical Society.)

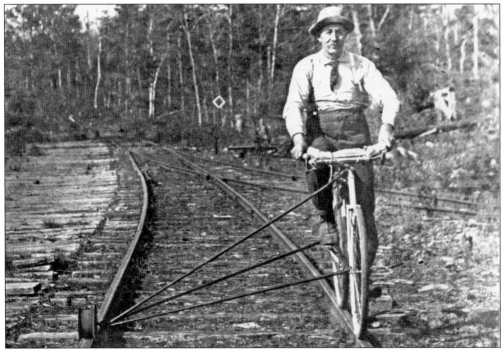

Martinsburg cattle dealer Charles Deloss Graves (1859–1934) purveyed meat to lumber camps on Tug Hill. To take orders, he rode a modified bicycle that allowed him to travel along the tracks of the Glenfield & Western Railroad. In 1902, Page and Fairchild Company sold both its forested land and its share in the railroad to Gould Paper Co. of Lyons Falls. By 1907, Gould was cutting between eight and nine million board feet of spruce annually. (Lyons Falls Historical Association.)

From the earliest days of settlement, Whitaker Falls on Roaring Brook has been a popular site for picnics and swimming. The location takes its name from Daniel Whitaker, who bequeathed 345 acres of his farm to the Town of Martinsburg for use as a park. E.M. Van Aken of Lowville took this photograph in the 1860s. (Lewis County Historical Society.)

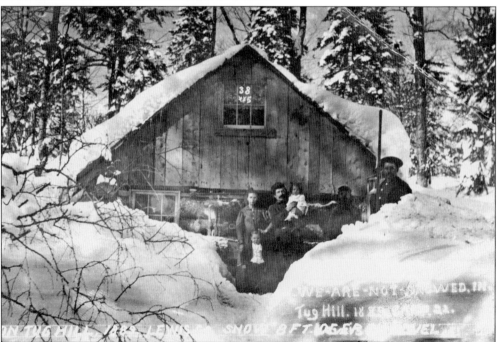

This photograph, dated 1889, shows a family at the Tug Hill lumber camp known as "22," located in what was once the Town of Highmarket and is now the Town of West Turin. The cabin is engulfed by eight feet of snow, yet the caption reads, "We are not snowed in." Some Tug Hill dwellings had second-story doorways, allowing inhabitants to enter and exit their homes when snow was especially deep. (Lyons Falls Historical Association.)

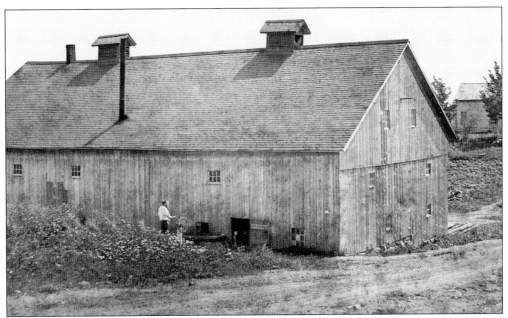

Shortly after the Civil War, dairy farmers began to realize increased income from the manufacture and sale of cheese. One of the largest cheese factories in Lewis County was that of Willet Vary, who began making New Columbia Cheese at his Harrisburg factory. Around 1910, the factory received milk from 1,000 to 1,200 cows and produced cream, whey butter, cream butter, pot cheese, and cheddar cheese. This photograph shows the East Harrisburg Cheese Factory about 1865. (Lewis County Historical Society.)

The hamlet of Barnes Corners, in the sparsely populated Town of Pinckney, is named for Elisha Barnes of Middletown, Connecticut, who arrived in 1805 and left several years later. Horace Lucas built the Lucas Hotel (pictured) around 1846. The structure was slightly south of where Barnes's log cabin once stood and where John Savell, in 1887, would build the three-story Barnes Corners Hotel. The Lucas Hotel was torn down in 1906. (Lewis County Historical Society.)

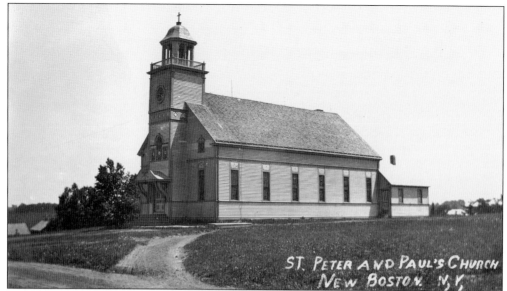

Between 1856 and 1860, Catholics built St. Peter's Church in New Boston. That structure was torn down in 1889 and replaced with the larger St. Peter & Paul's Church in 1897. To support the church, the parish held an annual picnic on or about August 15, drawing people from throughout the county. In 1948, more than a ton of beef was served to 7,000 people. (Lyons Falls History Association.)

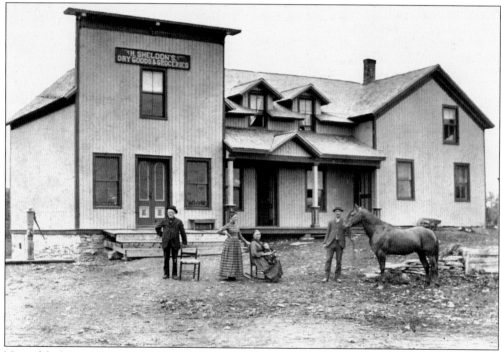

Named for Mary Montague Pierrepont, daughter of former landowner Hezekiah B. Pierrepont, the Town of Montague has never had an incorporated village, but it once had six small settlements. One of these was Rector's Corners, where Hezekiah Sheldon started a general store (pictured) in 1885 and, two years later, erected a sawmill. (Lewis County Historical Society.)

Four

BLACK RIVER CANAL

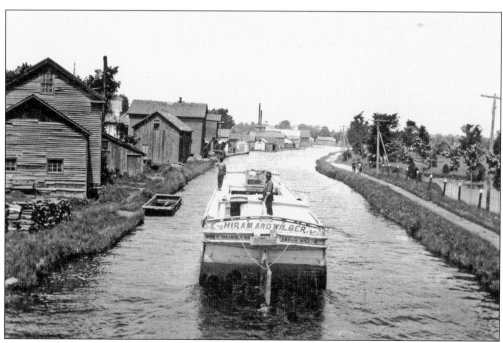

In 1837, the state legislature authorized funds to construct a canal that would traverse the county from north to south, linking Carthage, on Black River, with Rome, on the Erie Canal. The overland portion of the canal between Rome and Lyons Falls, a distance of 35.5 miles, was completed in 1855, with 109 locks that allowed boats to negotiate a rise-and-fall of 1,079 feet. (Vincent Fitch collection.)

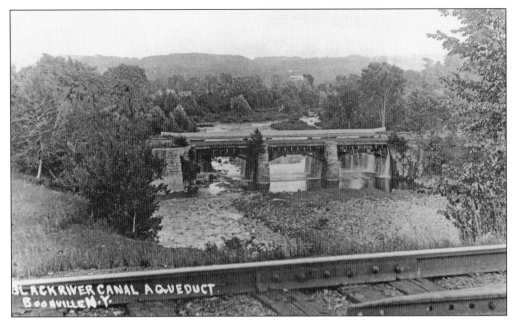

About four miles south of Port Leyden, a viaduct carried the Black River Canal across Sugar River. The structure was supported by three 40-foot wooden arches resting on limestone blocks. Wooden siding atop the viaduct struggled to contain the man-made river. (Lyons Falls History Association.)

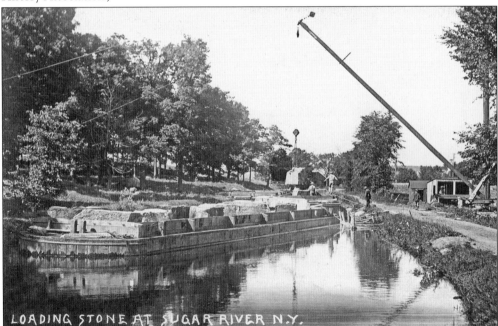

During the 1840s and 1850s, contractors built canal locks between Boonville and Lyons Falls using limestone from the Sugar River Quarry. Each lock measured 15 feet wide and 90 feet long. In this c. 1908 photograph, dimension limestone is being loaded into canal scows. The limestone was used to construct Delta Dam near Rome, part of the Barge Canal System, which was then under construction. (Larry Myers collection.)

70

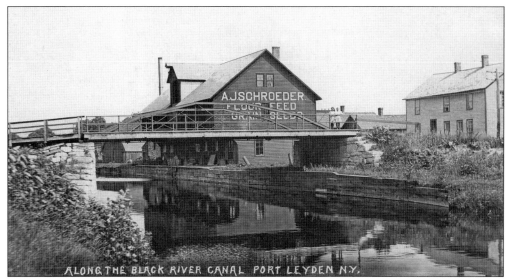

The feed and flour store in this photograph was built in 1866 and was located on the Black River Canal near the North Street Bridge in Port Leyden. August J. Schroeder acquired the mill from Milton Holt around 1900 and ran it for some 30 years. The canal served the commercial interests of the village, but it also offered recreational opportunities, lending itself as a swimming hole in the summer and a skating rink in the winter. (Ed Yancey collection.)

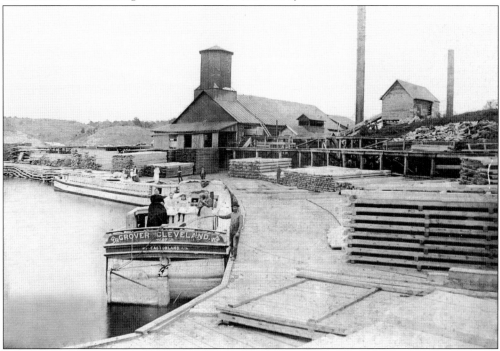

The Black River Canal made it possible to ship sawn lumber and forest products to distant markets. Lumber baron Theodore B. Basselin transported lumber on his own boats. Basselin, who was prominent in Democratic circles, commissioned John Seiter of Hawkinsville to build several of his boats, naming one for his friend Pres. Grover Cleveland (pictured) and another for Vice Pres. Adlai Stevenson. (Black River Canal Museum.)

The canal entered Black River above Lyons Falls, detoured around the bridge and high falls, descended through a series of locks, and re-entered Black River below the falls. The detour ran just to the west of the Gould Paper Mill (pictured). With the depletion of easily accessible forests and the introduction of logging railroads, the Black River Canal declined in importance and was abandoned around 1922. (Lewis County Historical Society.)

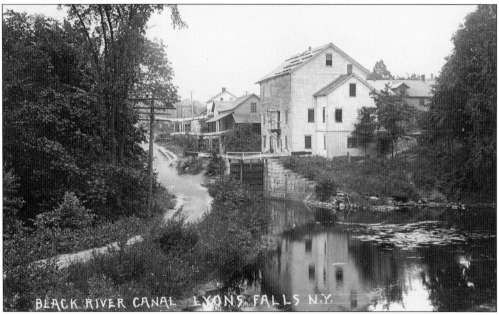

Locks 107, 108, and 109 are visible in this H.M. Beach photograph. These three locks mark the end of the overland portion of the canal and the beginning of the river portion. The large building at center right is Homer Markham's feed mill, erected in 1880, which was powered by canal water running through a sluice. (Ed Fynmore collection.)

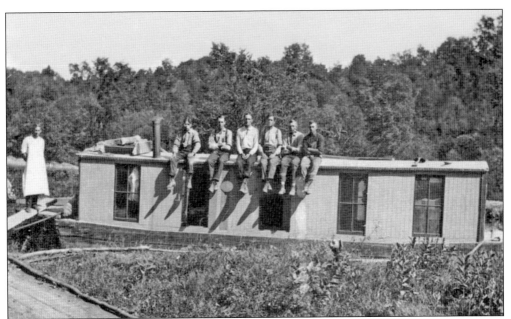

Canal locks suffered a great deal of wear and tear, and containment walls were subject to frequent breaks. To make repairs and keep the canal working properly, state crews were stationed at Lyons Falls and Boonville. These men traveled on horse-drawn state scows, called "hurry-up" boats, wherever they were needed. In 1879, the scow foreman was paid $50 per month, ordinary workers received $32, and the cook got $15. (Lewis County Historical Society.)

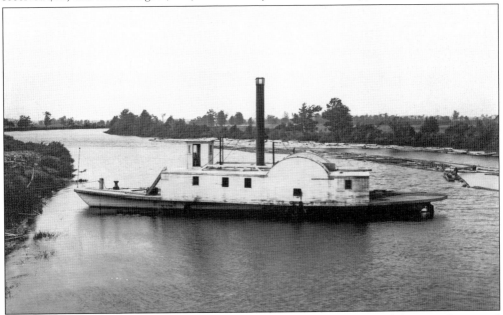

Horses and mules pulled canal boats on the overland portion of the canal, between Rome and Lyons Falls. Steamboats, like the *Edith B. Amber* (pictured), towed canal boats on the river portion of the canal, between Lyons Falls and Carthage, a distance of 42.5 miles. The river portion of the canal was completed in the 1860s with dams and locks at Otter Creek and Bushes Landing. (Lewis County Historical Society.)

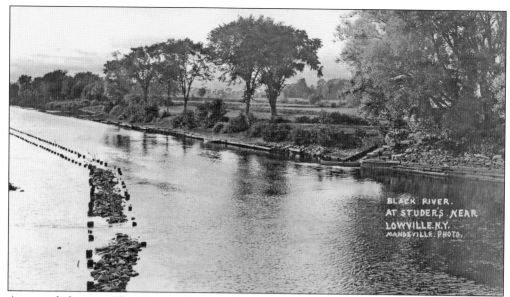

At several places on Black River, piling was driven into the river bottom to narrow channels and increase water speed in order to prevent sandbars from forming. Despite these measures, annual dredging was required. William Mandeville took this photograph near John Studer's Elm Grove Hotel at Watson. (Lyons Falls History Association.)

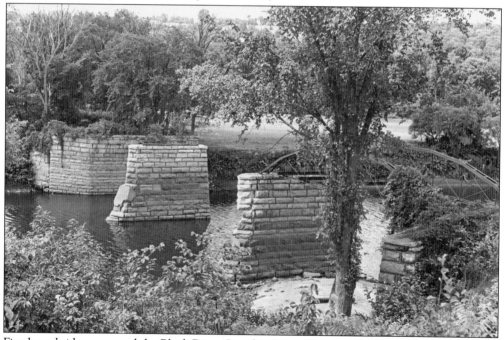

Five large bridges spanned the Black River Canal in Lewis County. They were located at or near Castorland, Watson (Beach's Bridge), Glenfield, Dadville (Illingworth Bridge), and Lyons Falls (Whittlesey Bridge). The Whittlesey Bridge, the ruins of which are seen here, was named for John Whittlesey, who built a log bridge above Lyons Falls in 1836. A veteran of the War of 1812, Whittlesey was too old for service during the Civil War, but he acquired the nickname "Captain" for his work as a recruiter. (Lyons Falls History Association.)

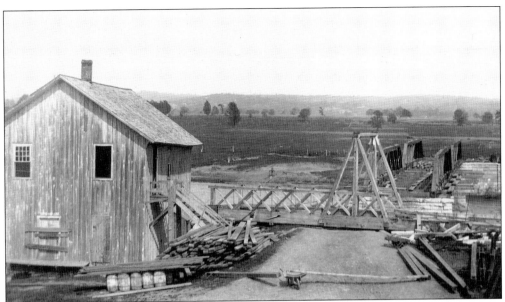

Lyman R. Lyon formed the Black River Steamboat Company in 1856 and launched the *L. R. Lyon*. This steamboat was piloted by Nelson Whittlesey and sported a cast-iron lion on its bow. The Glenfield Bridge, built in 1846, was removed when it proved to be an obstacle for Lyon's steamboat. This 1897 photograph shows a later swing-bridge at Glenfield undergoing repairs. (Paul Joslyn collection.)

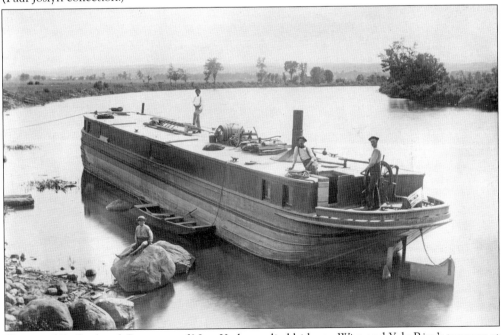

Sherwood Bullard and Company of New York supplied hides to Wirt and Yale Rice's tannery at Jerden Falls in the Town of Croghan. In 1879, the company built a steamer, the *Lucy H. Bullard*, to compete with the railroad. This Black River steamer, with its 20-horsepower engine, could travel at six miles per hour and reach Rome in two and a half days. This photograph was taken near Naumburg in the Town of New Bremen. (Lewis County Historical Society.)

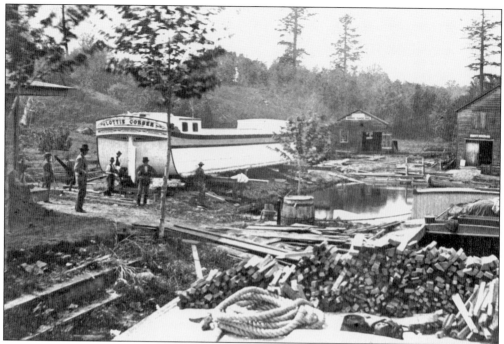

Around 1880, O.H. Cooke built the *Lottie Corser* at Jesse Irons's Lyons Falls boatyard. (Lyons Falls History Association.)

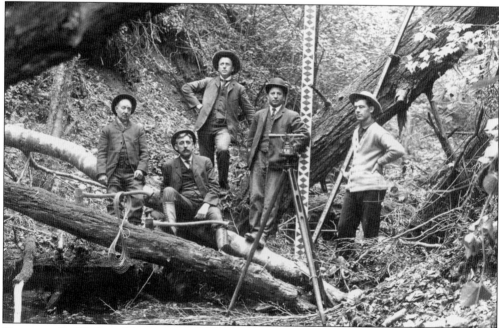

Known as the "Father of American Civil Engineering," Benjamin Wright began surveying Lewis County in 1796 and later became chief engineer on the Erie Canal. Nearly all of America's first civil engineers received their training by working on canal projects, many under the supervision of Wright. This c. 1908 photograph features engineers on the Black River Canal near Delta. (Arnold Weber collection.)

Five

SOUTHEAST LEWIS

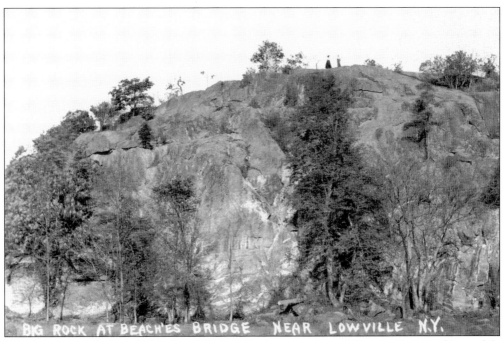

BIG ROCK AT BEACHES BRIDGE NEAR LOWVILLE N.Y.

The Adirondack Park, established in 1892, includes large portions of Watson, Greig, and Lyonsdale Townships. Soil in the three townships is sandy and generally unsuitable for most types of agriculture, as settlers gradually discovered. Between 1875 and 1930, the number of farms in Watson declined from 243 to 37. (George Davis collection.)

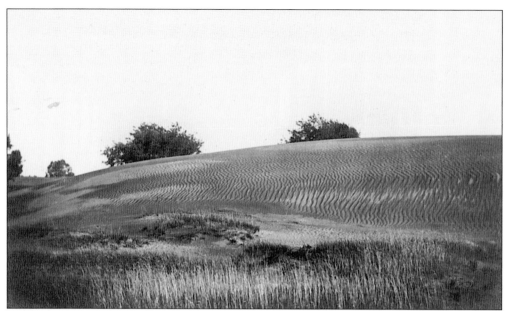

In 1799, sea merchant John Brown of Providence received 210,000 acres of land in the Adirondacks as payment for a shipment of tea. He divided his wilderness tract into 12 numbered townships. Number Four—one of the few hamlets in the Town of Watson—takes its name from Township No. 4 on Brown's map. The photograph above, taken in the 1920s, shows a sand dune in Watson. Decades of reforestation have made scenes like the one above quite rare in the eastern townships. (Larry Myers collection.)

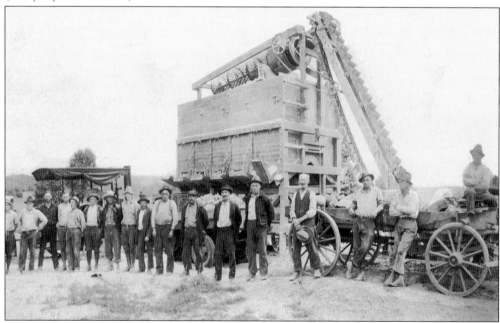

The Town of Watson has three county roads, the longest of which connects the hamlet of Watson on Black River with Number Four near the Herkimer County line. This photograph is an excerpt from a panorama by Henry M. Beach showing a road crew at work laying down a macadam road in Watson. (Lewis County Historical Society.)

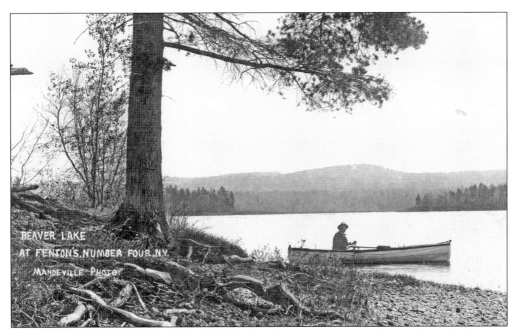

Beaver River originates at Lake Lila in Hamilton County and flows northwest through the Town of Watson, passing by Number Four, where it widens to form Beaver Lake. This photograph by William Mandeville features the elegant Adirondack guide boat. Light enough for one person to carry, the guide boat was tapered on both ends like a canoe but was rowed instead of paddled. (George Davis collection.)

Orrin Fenton (1784–1870) built Fenton House at Number Four in 1826. His son Charles (1829–1905) later placed an observation tower atop the hotel and built 18 rental cottages. Charles advertised Number Four as a sportsman's paradise "located in the wildest part of the Adirondacks." To reach the hotel, visitors boarded a buckboard at the Lowville train station and traveled 19 miles eastward over rough road. On arrival, guests often settled in for a stay that lasted most of the summer. (Lewis County Historical Society.)

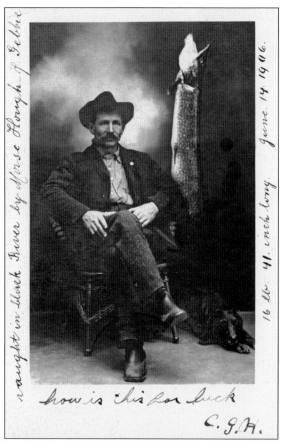

caught in Black River by Morse Hough & Gebbie June 14 1906. 16 lbs. 41 inch long.

how is this for luck

C. G. H.

Black River, north of Lyons Falls, is noted for its pike fishing. This image features a 16-pound, 41-inch great northern pike caught near the Illingworth Bridge by John Morse, T. Devalan Hough, and Dr. Alexander R. Gebbie in 1906. (George Davis collection.)

George Norton built the Stony Lake Hotel in the Town of Watson around 1892. Stony Lake was a favorite fishing spot of Watson native Henry M. Beach, who took this photograph. By 1892, the state had set limits on the size of brook trout but not the number that could be taken daily. In 1929, individuals were permitted to keep 25 brook trout daily as long as they did not total more than 10 pounds. (George Davis collection.)

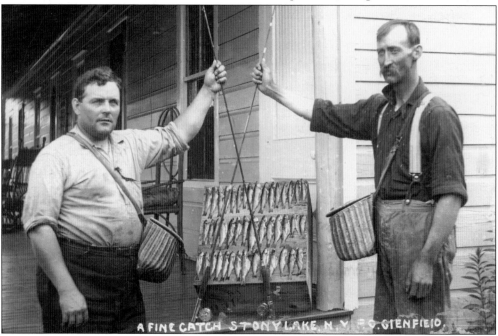

A FINE CATCH STONY LAKE, N.Y. H. O. GLENFIELD.

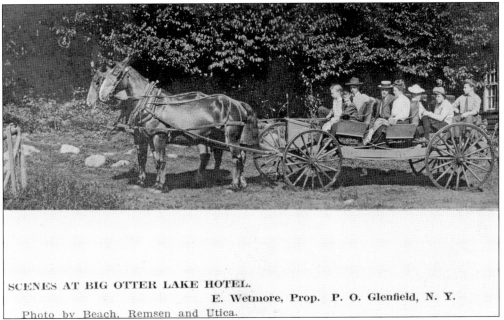

SCENES AT BIG OTTER LAKE HOTEL.

E. Wetmore, Prop. P. O. Glenfield, N. Y.

Photo by Beach, Remsen and Utica.

H.M. Beach produced this advertising postcard for Ezra Wetmore, Adirondack guide and proprietor of Big Otter Lake Hotel. Visitors would arrive at Glenfield on the Rome, Watertown, & Ogdensburg Railroad and then take a buckboard eastward through the wilderness. Big Otter Lake lies on the border of Herkimer County. (Lyons Falls History Association.)

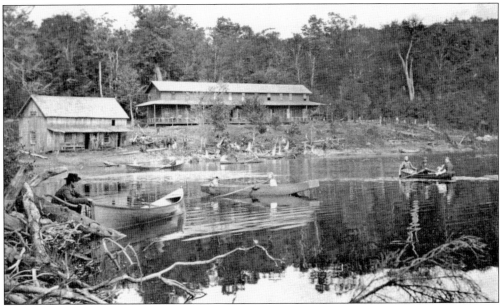

Big Otter Lake was highly regarded for its fishing. A sportsman might easily take 100 to 200 brook trout over the course of a week. This photograph by H.M. Beach shows Big Otter Lake Hotel as it appeared in 1891, when its builder, Frank Burdick, was still running the establishment. In 1916, the state claimed the land on which the hotel was built. Forced to vacate the property, proprietor William D. Crandall moved to Brantingham Lake and leased Long Point Inn. (Lyons Falls History Association.)

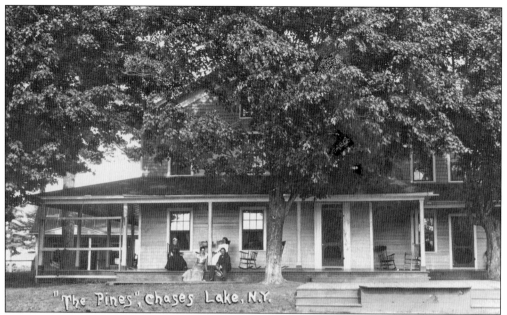

"The Pines", Chases Lake, N.Y.

With its tall pines, sandy beaches, and five miles of shoreline, Chase's Lake in the Town of Watson has long been a tourist attraction. During the Civil War, Capt. Leroy Crawford (1834–1916) protected wagon trains crossing the Great Plains. After the war, he ran a sawmill at Chase's Lake and, from 1896 to 1914, operated "The Pines." Known locally as "Millionaires Inn," the resort attracted prominent guests such as Pres. Grover Cleveland, Harry Payne Whitney, and Lt. Gov. Timothy L. Woodruff. Fire destroyed the hotel in 1923. (Larry Myers collection.)

"The Pines, CHASES LAKE N.Y.

In 1920, Leroy Crawford's heirs, Mary Crawford and Anna E. Crawford, sold all of Chase's Lake, along with 1,100 acres of land and various cottages. Later that year, the new owners conveyed the property to Lingerlong Estates Corporation of Boonville, in which Donald Douglass and William D. Hough were principal stockholders. On discovering the water of nearby Hinching's Pond to be mildly radioactive, Hough bottled the water and sold it for medicinal purposes. (Lyons Falls History Association.)

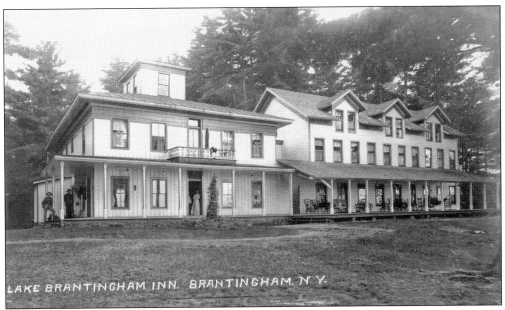

LAKE BRANTINGHAM INN. BRANTINGHAM. N.Y.

When George A. Graves built the Brantingham Inn (left) in 1876, it was the only building on the lakefront; an earlier hotel built in 1856 and operated by David L. Lovejoy and James H. Lampman burned in 1874. Graves's son Leon F. built an annex (right) in 1895. The hotel featured a dining room capable of seating 100 guests, and it had an ice cream parlor in the basement. During inclement weather, guests played bridge in the old lobby. (Larry Myers collection.)

Swimming, boating, tennis, fishing, horseback riding, and hiking were popular diversions at Brantingham Inn. Dances were held in the boathouse. Golf became available around 1919, when Leon Graves opened a nine-hole golf course with greens featuring rolled sand rather than grass. In the photograph, a family of tourists is on a nature walk with some expectation of encountering butterflies. (George Davis collection.)

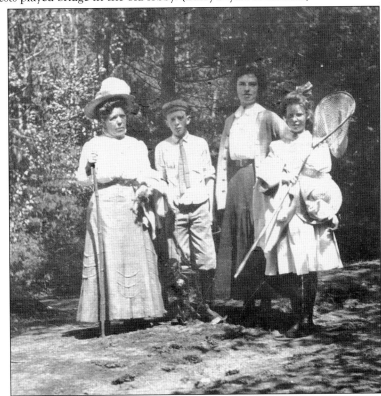

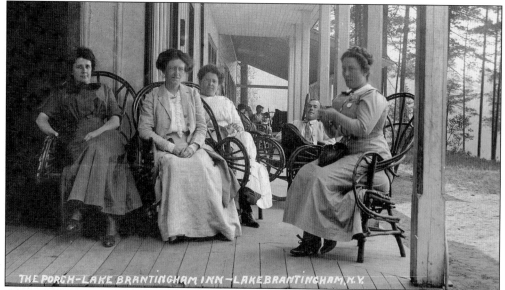

THE PORCH-LAKE BRANTINGHAM INN-LAKE BRANTINGHAM, N.Y.

Adirondack resorts in Lewis County typically featured verandas that ran the length of the hotel. In this H.M. Beach photograph, guests at the Brantingham Inn sit in chairs fashioned in the rustic twig style characteristic of much Adirondack furniture. From the porch, guests could watch the campfire that was lit every evening during fair weather. (Lyons Falls History Association.)

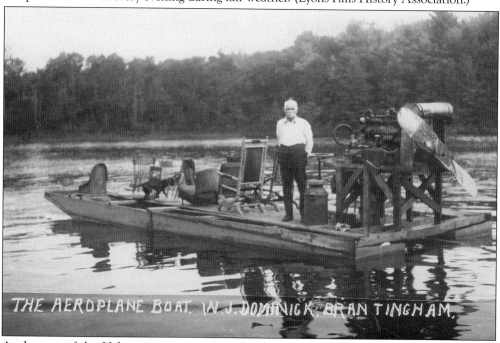

THE AEROPLANE BOAT. W. J. DOMINICK, BRANTINGHAM.

At the turn of the 20th century, some 150 individuals were breeding, raising, or selling graded livestock in Lewis County. One of these was William J. Dominick of Greig (above), who dealt in registered Berkshire hogs and Holstein cattle. In 1932, Dominick launched a homemade airplane boat on Brantingham Lake. With its six-foot-long propeller and 70-horsepower Chrysler engine, the craft could attain a cruising speed of 10 miles per hour. Dominick charged school children 10¢ and adults 25¢ for a 50-minute tour of the lake. (Lyons Falls History Association.)

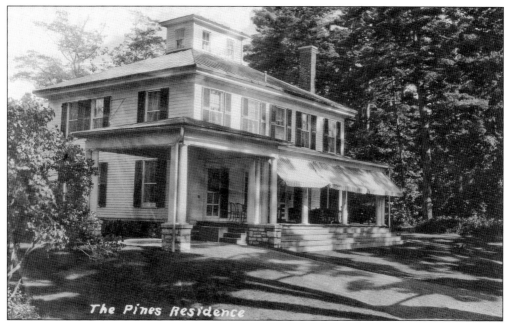

The Pines Residence

In 1819, Caleb Lyon Sr. became the first permanent settler in Lyonsdale. His oldest daughter, Laura, married Francis Segar, who as a state senator was instrumental in securing legislative approval for the Black River Canal. In 1826, Segar built the Pines in Lyons Falls on a rise overlooking the Old French Road, which the Castorland Company had blazed from Fort Schuyler (Utica) to Castorville (Beaver Falls). (Lyons Falls History Association.)

Caleb Lyon Sr. (1761–1835) served as a land agent for John Greig in the Brantingham Tract, a large expanse of wilderness from which the Towns of Greig and Lyonsdale were formed. After purchasing a large section of the Brantingham Tract for himself, Lyon built a covered bridge across Moose River in 1829 and a gristmill the next year. This photograph by Dante Tranquille features a scenic stretch of Moose River near the settlement of Lyonsdale. (Author's collection.)

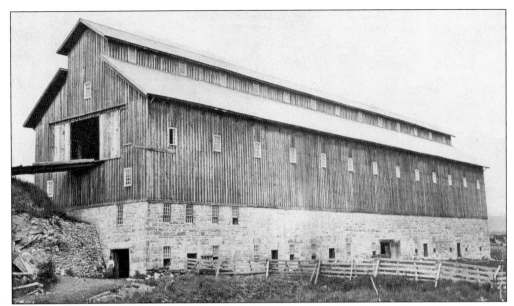

Caleb Lyon's elder son, Lyman (1806–1869), operated an 800-acre farm in Lyonsdale, where he built what was then the largest barn in the state. Erected between 1859 and 1869, the four-story barn measured 221 feet by 48 feet, with enough space to house 200 cows and 650 tons of hay in mows on the ground floor. The basement contained machinery for threshing, cutting roots, and feeding livestock, all operated by waterpower. This structure serves as a thematic center in Walter D. Edmonds's 1930 novel *The Big Barn*. (Lyons Falls History Association.)

Caleb Lyon's younger son, Caleb (1822–1875), was named US consul to Shanghai in 1847, but he delegated his duties to a deputy and moved to California, where he prospected for gold. In 1849, he was chosen as secretary of the California Constitutional Convention and designed the state seal. In 1864, Pres. Abraham Lincoln appointed him first governor of Idaho Territory. There, he had some success in establishing peaceful relations with the Shoshone and Nez Perce, but he outraged many settlers when he transferred the capital from Lewiston to Boise. (Lyons Falls History Association.)

Located about one mile east of Lyons Falls, Gouldtown takes its name from Gordias Henry Plumb Gould (1848–1919), who, in partnership with Lyman Lyon's three daughters, operated a sawmill and pulp mill there. Gould went on to become president of the St. Regis Paper Co. and the Donnacona Paper Co. of Quebec, all while preserving the independence of Gould Paper Co. This photograph features the general store at Gouldtown. (Lyons Falls Historical Association.)

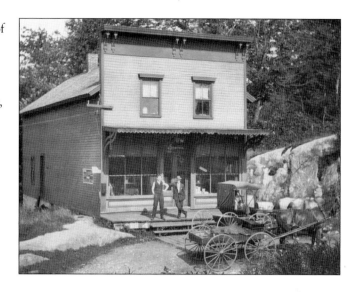

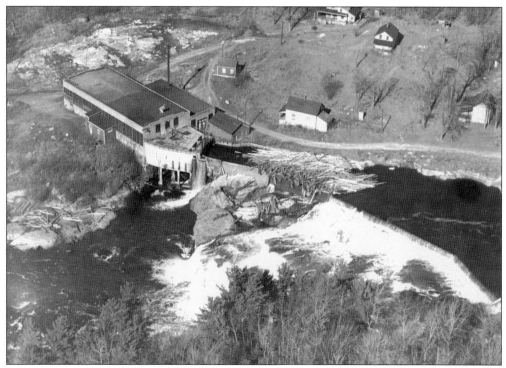

Maj. John S. Koster supervised the Herkimer Paper Company's operations at Kosterville on Moose River. In 1883, the Kosterville mill had eight grinding stones capable of producing 16 tons of pressed pulp daily, which was then shipped to paper mills for further processing. International Paper Company acquired the Kosterville property in 1895, at which time the settlement boasted two mills, 14 homes, a large boardinghouse, and the only school in Lyonsdale. This photograph dates from 1946. (Lyons Falls History Association.)

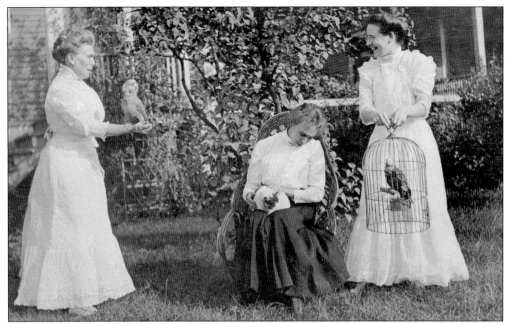

Col. James T. Outterson and his son James Andrew Outterson established a wood pulp mill at Lyonsdale. In 1923, John W. Moyer of Greig and Charles W. Pratt of Boonville acquired the property and set up a factory to manufacture tissue paper. Walter Pratt succeeded his father in 1935, and Olive Moyer (left, with cockatoo) succeeded her husband in 1938. The firm of Moyer and Pratt ceased production in 1961. (Lyons Falls History Association.)

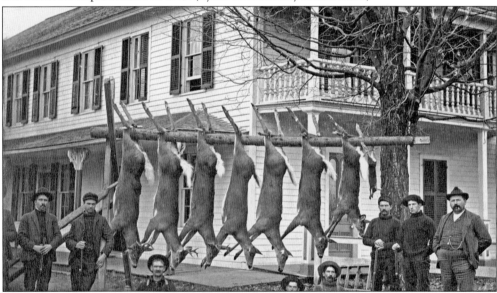

In 1859, Abner Lawrence and his family moved to Fording Place (later, Moose River Settlement), where he set up housing in two large packing crates. After catering to sportsmen and tourists for a number of years, Lawrence built the Moose River Hotel. Disgusted by the despoliation of the nearby Mammoth Tannery, he sold his hotel in 1875 and removed to Boonville. In this photograph, Burt Morehouse, one of the hotel's many proprietors, is at far right. (Lewis County Historical Society.)

Six

FOREST INDUSTRY

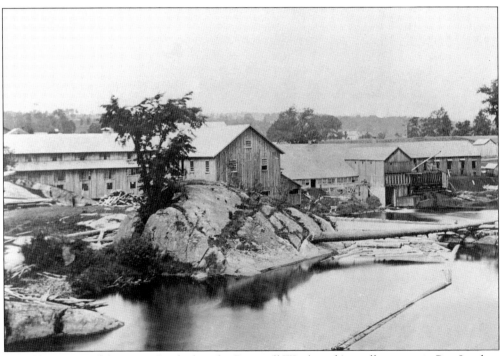

In 1855, Henry and Augustus Snyder bought Cornwall Woolworth's small tannery in Port Leyden. After expansion (above), the tannery employed 300 men and was turning out 40,000 sides of sole leather a year. The tannery burned down in 1875 and was not rebuilt. To sustain production for 20 years, a tannery such as the Snyders' might require 50,000 acres of hemlock. By 1895, only two tanneries remained in Lewis County (one at Harrisville and one at Jerden Falls), both owned by United Leather Company. (Lewis County Historical Society.)

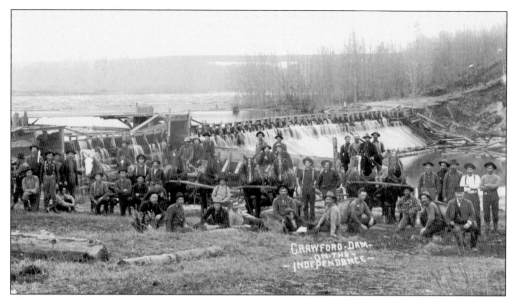

Around 1871, W.D. Lewis and Leroy Crawford built a plant to produce tannin extract from hemlock bark. This factory, on Independence River near the outlet to Chase's Lake, had the capacity to manufacture 3,500 barrels of extract annually. Early tanneries had often let peeled hemlock rot, but by the 1870s, entrepreneurs had begun to appreciate the value of hemlock timber. To transport hemlock logs to its two sawmills, Lewis and Crawford built a five-mile-long tram. (Larry Myers collection.)

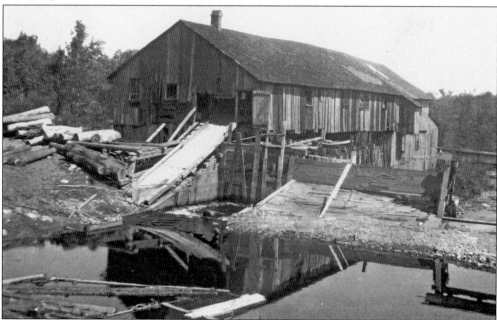

Early sawmills were small, intended only to meet the needs of their local communities. Sash gang saws—multiple saws arranged in parallel and set in a reciprocating frame—came into use in the 1840s, and around the middle of the century, lumber was on the way to becoming an important regional export. In the late 1890s, Chester H. Kimball built this sawmill, which was near Oswegatchie Corners in the Town of Diana. (Town of Diana Historical Society.)

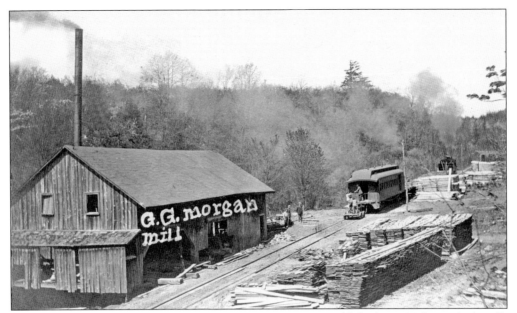

Hamilton Child's *Lewis County Gazette and Business Directory*, published in 1872, lists 112 sawmills operating as commercial enterprises. One of these was near Houseville. Luther Morgan erected the mill in the early days of settlement and continued to operate it until his death in 1870, when his son George took over, sawing elm for cheese boxes and maple for furniture. The Glenfield & Western Railroad reached the mill in 1902. (George Davis collection.)

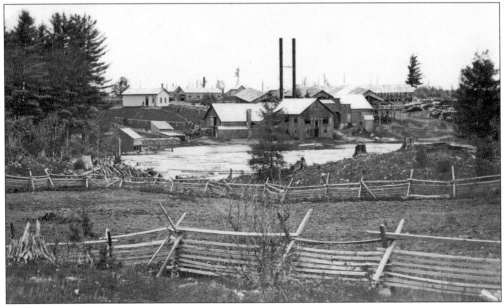

In 1866, George H. Crandall purchased a sawmill on the Independence River. William H. Dannat and Charles E. Pell acquired the property in 1876 and within a few years had converted the old mill to steam power and erected a second mill with an 80-horsepower steam engine. The Dannatberg mills turned out dimension lumber as well as parts for toys, tables, and bedsteads, all of which was shipped to New York City, where Dannat and Pell's lumberyard covered some 42 city blocks. (Lyons Falls History Association.)

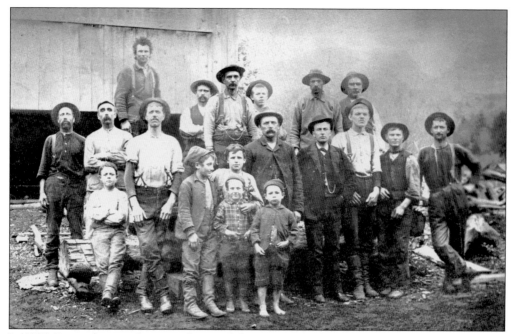

In 1885, Dannatberg, with its population of about 200, was the only settlement of any size in the Town of Watson. In addition to the mills, the settlement had homes for about 40 families, as well as a post office, store, school, and blacksmith shop. On a nearby island in the Independence River, William Dannat built himself a mansion that featured a mansard roof and stained-glass windows. (Lyons Falls History Association.)

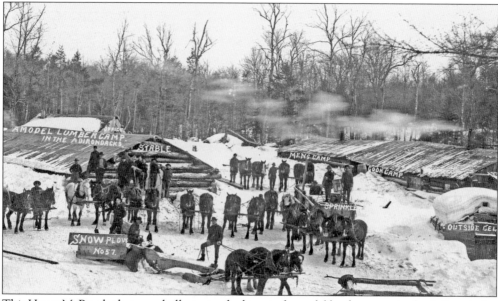

This Henry M. Beach photograph illustrates the layout of a model lumber camp in the Adirondacks. A long horse stable appears on the left, with an equally long building on the right with sleeping quarters in the rear and a mess hall and kitchen in the front. A snowplow, sprinkler wagon, and log sled are also shown, along with a cold cellar. A large camp might also have an office, small store, and blacksmith shop. (George Davis collection.)

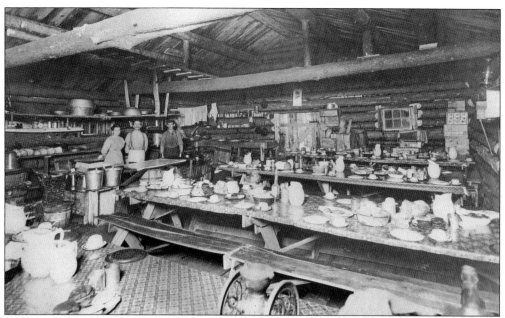

Working 10 hours a day, woodsmen developed ravenous appetites. For breakfast alone, a man might consume 10 pancakes and as many boiled eggs. Logging camps frequently kept livestock for fresh eggs, milk, and meat. Because of the long hours and hard work involved in food preparation, female cooks in the 1890s were often paid $30 per month—about as much as the loggers themselves. Taken at McKeever in 1911, this photograph features (left to right) cooks Clara and Henry Stevens and helper Hershell Irvin. (Town of Diana Historical Museum.)

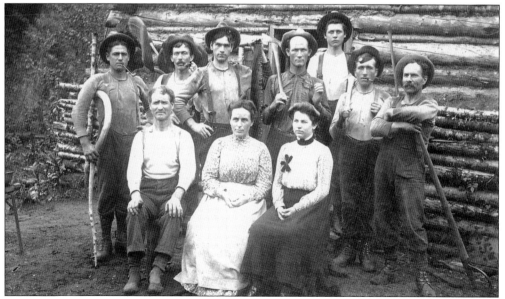

In the mid-1800s, a logger using an ax typically cut an average of 70 logs a month. For that labor, he received $25 to $39. The use of crosscut saws, which allowed a pair of loggers to cut approximately 160 logs per month, became more widespread in the Adirondacks during the 1890s. This photograph was taken near Pine Lake in 1902; notice the homemade crutch propping up the worker at left. (Lewis County Historical Society.)

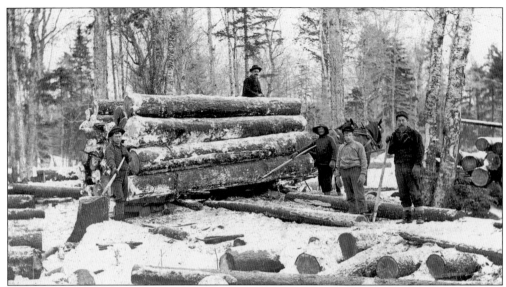

Although spruce comprised less than 15 percent of the Adirondack forest, it was the tree of choice for both saw logs and pulpwood because it was buoyant and could be floated to mills downstream. For saw logs, spruce was cut into a standard 13-foot length with a 19-inch diameter at the top. In 1901, the average spruce tree was 70 feet high with a clear trunk of 46 feet, yielding about three and a half merchantable logs. (Larry Myers collection.)

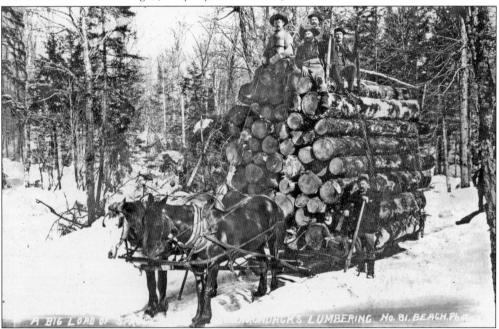

Adirondack red spruce has long set the acoustic standard for guitar and piano sounding boards. The Martin guitar company and Steinway & Sons piano company, among others, have prized the rich resonance of Adirondack spruce. In the late 1870s, Alfred Dolge began sawing virgin spruce at a mill on Otter Creek. This wood was then transported to his factory in Brockett's Bridge (now Dolgeville in Oneida County), where it was fashioned into piano sounding boards. (Lyons Falls History Association.)

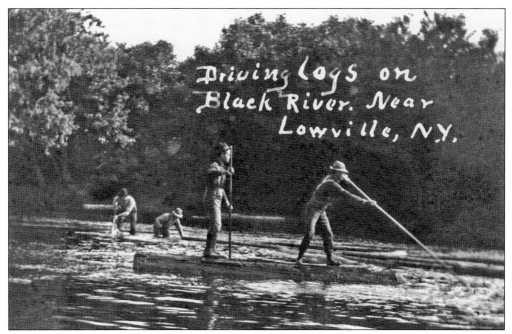

By 1879, the Gould Paper Company was driving some 14 million board feet of spruce logs in the Black River watershed annually. As easily accessible logs became depleted, the cost of spruce rose dramatically. In the late 1880s, a cord of spruce pulpwood sold for $2 at a Black River mill, but by 1896, it would fetch $6.50 or, if debarked, $10.50. (George Davis collection.)

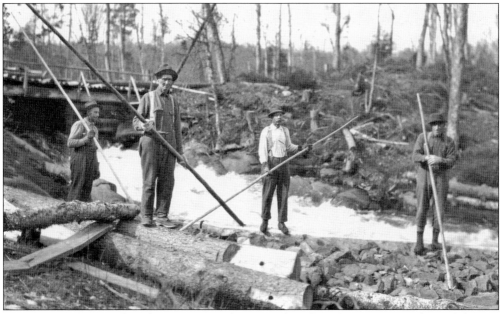

The driver's job was to keep logs moving and prevent them from forming jams. The workday was long—typically beginning at 5:00 a.m. and lasting until 8:00 p.m. Around 1890, good drivers earned $2.50 a day. Major log drives occurred on the Beaver, Black, Moose, and Oswegatchie Rivers, but even smaller streams such as Independence River, seen here, were capable of sustaining a drive. (Lewis County Historical Society.)

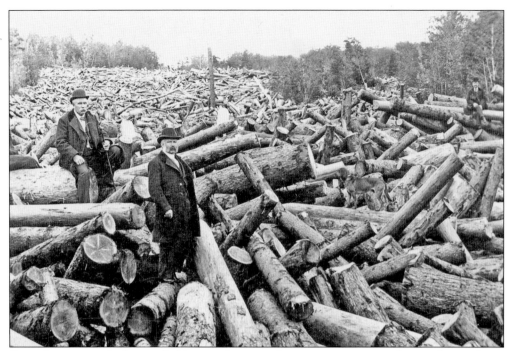

Borne by a strong freshet, peeled logs might move downstream at a rate of two miles per hour. Wing jams formed when logs caught on a bank and extended out into the river. More complex jams formed when logs caught on a boulder in the river, causing logs behind it to pile up chaotically. To provide additional water for the drive, loggers dammed tributaries to the main waterway in order to form ponds, often 30 acres large, from which water could be released as needed. (George Davis collection.)

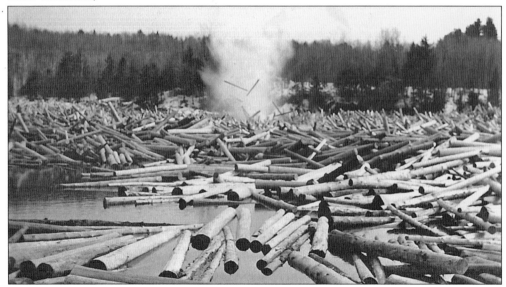

Loggers frequently worked from 14-foot jam boats as they sought to identify and dislodge the key log causing the blockage. When a jam began to break, loggers depended on the skill of the boatman for a successful retreat. This 1947 photograph was taken on Moose River when a one-mile-long jam formed; several cases of dynamite were needed to break it. (Larry Myers collection.)

In 1912, Edward Jones started the first reforestation project in Lewis County on land owned by the Adirondack Water Works in the Town of Watson. Reforestation on a larger scale began in 1921, when the state established a 95-acre tree nursery at Dadville. By 1927, 11 million trees had been transplanted and another 28 million were growing at the nursery. During the 1930s, the Dadville nursery provided the Civilian Conservation Corps in Harrisville with evergreen trees. This photograph dates from 1930. (Lewis County Historical Society.)

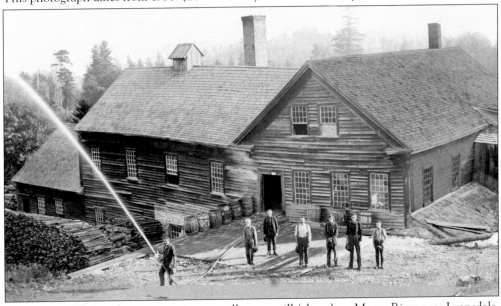

In 1848, Joel W. Ager began operating a small paper mill (above) on Moose River near Lyonsdale. Using rag fiber to manufacture printing and wrapping paper, Ager's mill remained a going concern for nearly 50 years. In the early 1870s, Jacob Hurst and John Moyer had a paper mill at Lyonsdale—the only other one in Lewis County at the time. During the 1870s, American paper mills began to experiment with various combinations of rag and wood fiber. (Lyons Falls History Association.)

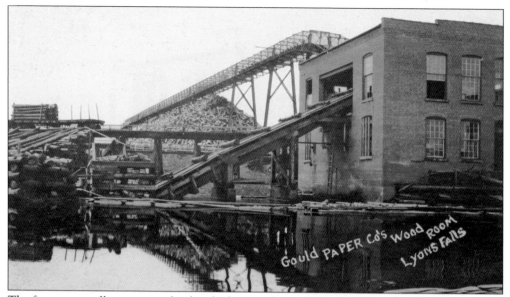

The first paper mills to use wood pulp relied on mechanical grinders to separate the fibers. In the 1880s, paper mills began using chemicals, such as sodium hydroxide and sulfuric acid, to break down the lignin that bound the fibers. To manufacture sulfuric acid, the Gould Paper Co. in Lyons Falls (pictured) built its own sulphite mill in 1900, allowing the firm to control the chain of production from start to finish. (Lyons Falls History Association.)

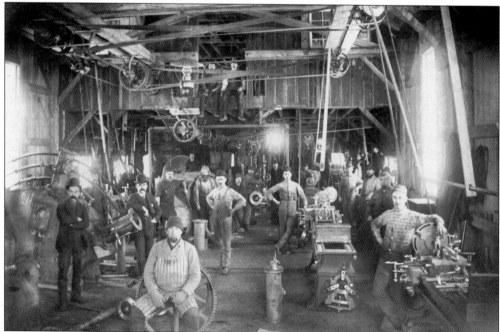

In 1887, J.P. Lewis introduced a mechanical grinder that used an array of hydraulic pistons to press pulpwood against a grinding stone. To produce pulp, logs are reduced to piles of more or less uniform chips, which are then placed in a digester, where they are subjected to a pressurized bath of sulfuric acid. The pulp is then washed, bleached, and—along with clay, sizing, and other chemicals—placed in a beater. This photograph dates from 1895. (Town of West Turin.)

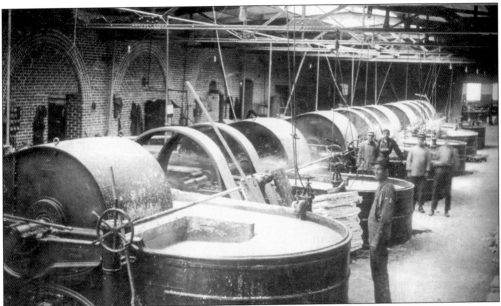

A beater is a large oval tank that typically contains two sets of blades, one attached to a stationary plate and the other to a moving plate. As the pulp circulates in the beater, bundles of fibers are separated, combed out, and made more pliable. This image shows the six beaters of the Gould Paper Co. at Lyons Falls. (Lyons Falls History Association.)

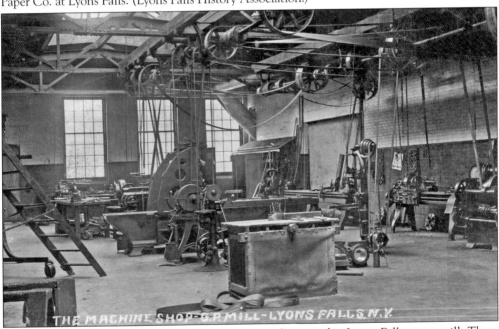

G.H.P. Gould initially installed two Fourdrinier machines in his Lyons Falls paper mill. These machines produce a continuous flow of pulp over a fine-mesh wire screen, allowing paper to be manufactured in rolls rather than sheets. To maintain these machines, the Gould mill set up a shop (pictured) to manufacture needed tools and parts. Machinery in the mill was driven by an elaborate array of pulleys connected to the shaft of a waterwheel beneath the mill. (Lyons Falls History Association.)

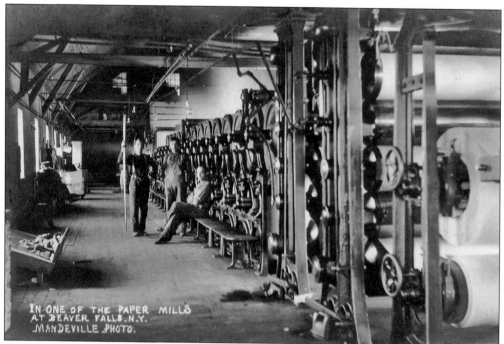

In one of the paper mills at Beaver Falls, N.Y. Mandeville Photo.

This William Mandeville photograph shows a Fourdrinier machine at one of the J.P. Lewis paper mills. Refined pulp from the beater room is laid on a wire screen, where it is drained of water. On a felt-lined conveyor, the paper moves through a series of presses to remove the remaining water. The paper is then squeezed against heated cylinders and dried. Finally, the paper is run between calenders, which smooth the paper and impart the desired finish, thickness, and gloss. (Author's collection.)

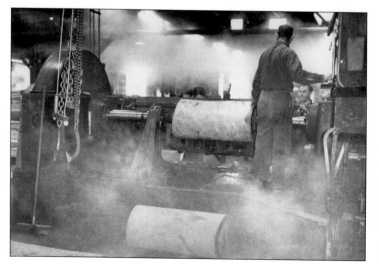

Lewis County has been celebrated for fine hardwood veneers since the mid-1800s. In 1950, Lowville Veneer Works purchased John Bacon's basket factory on South State Street. Veneer was cut from birch logs steamed in four vats, each of which had a 10,000-foot capacity. The steamed logs were then cut on rotary lathes (pictured). (Croghan Free Library.)

Seven

SOUTHWEST LEWIS

THREE WAY BRIDGE. LYONS FALLS N.Y. Photo: by H.M.BEACH Lowville.

Located at the junction of Black River and Moose River, the Village of Lyons Falls lies partly in the Town of West Turin and partly in the Town of Lyonsdale. In 1915, a new three-way bridge (above) replaced one built in 1853. The trussed span on the right extended across Black River, bifurcating near the eastern bank. A second trussed span extended across Moose River (left) and connected with a road to Greig, and a shorter span connected with the road to nearby Gouldtown. (Lyons Falls History Association.)

Gordias Henry Plumb Gould formed the Gould Paper Company in 1892 with junior partners Charles W. Pratt of Boonville and John E. Haberer of Lowville. This H.M. Beach photograph shows the Gould residence (upper left) overlooking Black River. Beneath the house sits the company office, and directly beneath the office, a Whipple bow-truss bridge (center) extends across the Black River Canal. (Lyons Falls History Association.)

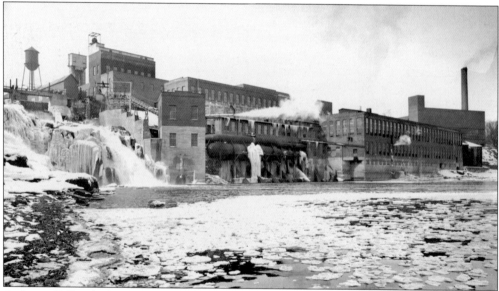

At Lyons Falls, Black River cascades 70 feet over gneiss bedrock, making it an excellent source of hydropower. The Gould Paper Co. operated mills in Fowlerville, Kosterville, Shuetown, and Port Leyden, but its paper and pulp mill at Lyons Falls (pictured), which opened in 1895, was by far the largest. In 1906, G.H.P. Gould formed a utility that provided electricity to Lyons Falls, Constableville, and Turin, and in 1907, his mill became the first in the country to employ an electrically powered paper machine. (Lyons Falls History Association.)

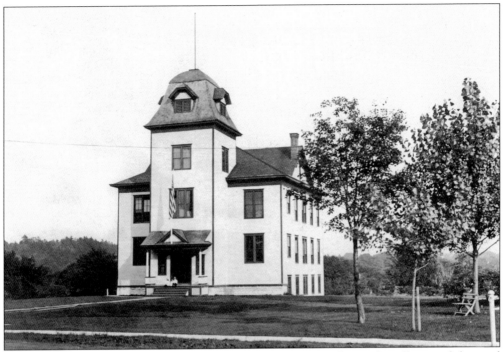

The opening of the Gould mill in Lyons Falls attracted new families to the village, and the need for a new school was soon evident. In 1895, the village purchased a lot on McAlpine Street for $500 and erected a three-story wooden school at a cost of $8,000. The new school accommodated eight grades and a high school. (Lyons Falls History Association.)

The first principal of the new school, Sam Neff, received an annul salary of $900, while preceptress Anna Moore earned $425, and Mary Cox, who taught primary school from 1901 to 1937, initially received a weekly salary of $7. A larger, brick school replaced the wood-frame school in 1927. (Lyons Falls History Association.)

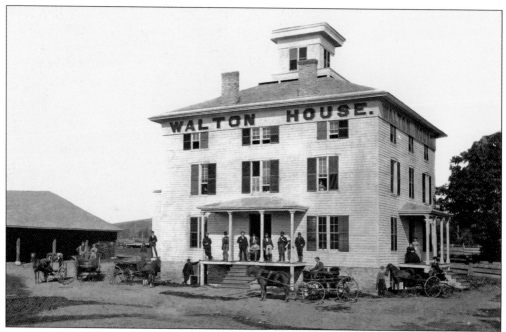

In 1851, Christopher Gould, veteran of the War of 1812, built a summer boarding establishment initially known as "McAlpine House" and later as "Walton House." The structure, which overlooked the Black River Canal, burned down in 1901. Six years later, Watson M. Shaw converted Archibald McVickar's nearby store into the "New Walton House." (Anna Laura Markham collection.)

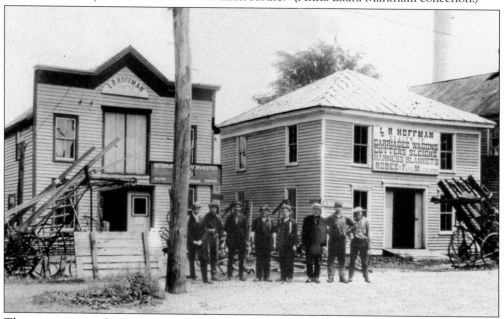

The growing popularity of the automobile in the early 1900s threatened the livelihood of blacksmiths. Lawrence R. Hoffman adapted by selling International Harvester equipment and an array of other products. John Walsh, another blacksmith, stayed in business by shoeing mules for canallers and forging peaveys, pike poles, and cant hooks for loggers; samples of his work are on display at the American Maple Museum in Croghan. (Lyons Falls History Association.)

For decades, Leo Carl cut hair and shaved beards in Lyons Falls. In this 1911 photograph, he is with an unidentified customer in his shop over Blodgett's store on Center Street. On the door behind Carl is a poster for the Haberle Brewing Co. of Syracuse, and to the right of that, a rack with the shaving mugs of regular customers. (Lyons Falls History Association.)

In 1886, after serving 12 years as Lyons Falls stationmaster, Charles M. Waters (left) resigned his position and entered the dry goods business with Maj. John S. Koster of Port Leyden. Waters later acquired Koster's interest and in 1905 purchased the Jeremy Upright building on McAlpine Street. The store was the site of the local post office during Benjamin Harrison's administration, from 1888 to 1892. (Lewis County History Society.)

Women found companionship in groups such as the sewing circle pictured here, which met in the home of Cora Waters. Martinsburg native Walter Hunt invented the lockstitch sewing machine in 1834 but declined to patent it, fearing that it would cause unemployment. Although sewing machines came into widespread use during the 1850s, they were expensive, costing around $125—a high price at a time when the average annual family income was less than $500. (Lyons Falls History Association.)

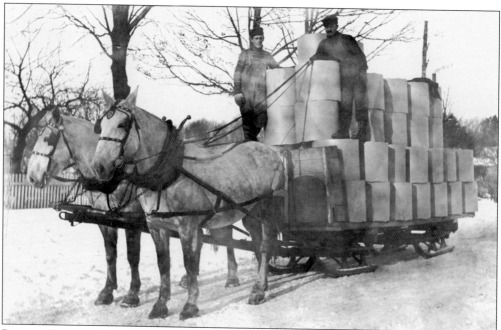

Paper mills along Moose River shipped finished rolls of their product to the Lyons Falls train station. In summer, horse-drawn wagons transported the paper, but during the winter, the mills used sleighs. (Lewis County Historical Society.)

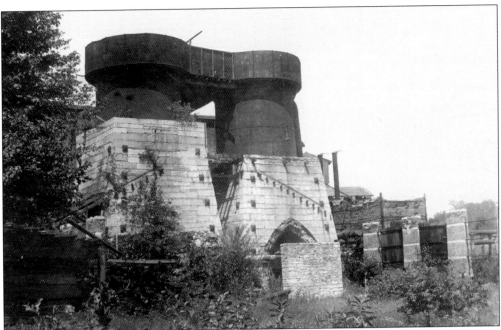

Port Leyden's economy, like that of other communities in Lewis County, centered on farming, tanning, and lumbering. For a while, however, it seemed as if mining would dominate the local economy. In 1865, the Port Leyden Iron Co. organized to process rich deposits of magnetite found within the village limits. Existing technology, however, was unable to remove impurities in the ore, notably titanium, and so the enterprise foundered. This photograph by Leon Smithling shows the twin furnaces, "Gracie" and "Fanny." (Lewis County Historical Society.)

On October 25, 1889, a fire began at Hood, Gale, and Co., a Tug Hill veneering firm that had a finishing room in the basement of the Douglass Opera House. Twenty-five buildings in Port Leyden's business district were destroyed, including those pictured—from left to right, they are the drugstore of Dr. David D. Douglass, erected in 1862; a clothing and furniture store built in 1866; Timothy Crowley's shoe store, constructed in 1870; and the Union Hotel, built in 1870. (Lyons Falls History Association.)

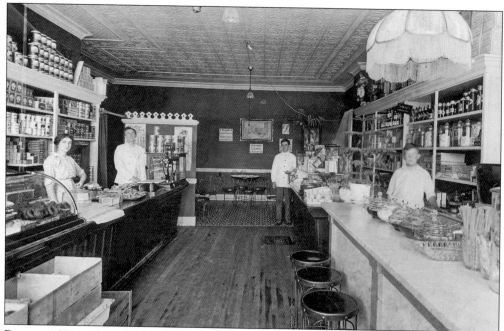

Between 1901 and 1919, Rauhe's Bakery and Confectionary Store in Port Leyden shipped bread north to Watertown and south to Utica. The store claimed to have the first soda fountain in Lewis County. Pictured in this c. 1913 photograph are, from left to right, Lillian Moshier Hamblin, Ben Rauhe, Dewitt Wiley, and Francis Rauhe. (William Hamblin collection.)

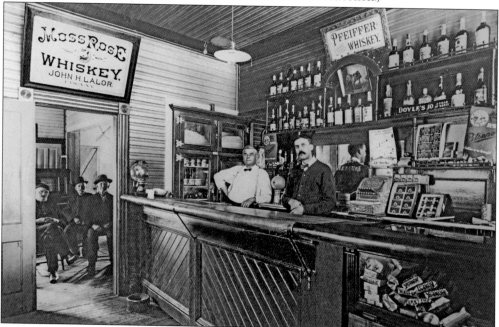

In 1895, when Capt. Charles Hammill ran this Port Leyden saloon, the community had six other watering holes as well as two hotels, the Brunswick and Powers House. Hammill later conveyed his establishment to John Snyder. Pictured from left to right are unidentified, George Homan, Al Homan, Brom Willis, and John Snyder. (Lyons Falls History Association.)

In the 1870s, C.D. Dewey operated the Iron City Flour Mill on Black River. With improved transportation, it became possible to import flour from the Midwest for less than it cost to produce it locally. Photographer E.E. Kellogg created this advertising card for Manfred Bibbins and Guy Wilcox's grocery store in Port Leyden. The children are happy because they eat Campbell's Olden Flour, imported from Blooming Grove, Minnesota. (Larry Myers collection.)

The Port Leyden Building and Improvement Co. organized in 1907 and, that same year, erected a building, which it leased to the Port Leyden Knitting Company. By 1910, the mill had 49 sewing machines working to produce children's underwear. (Larry Myers collection.)

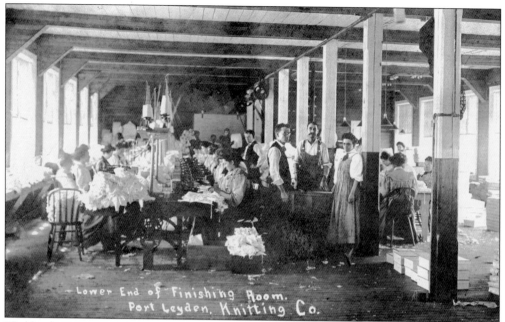

The finishing room of the Port Leyden Knitting Co. appears on the left, while the packing room is on the right. In 1907, a female employee, depending on her level of skill, might earn anywhere from $2.70 to $10.80 for a 54-hour week. Standing in the center of the photograph are Supt. John Fogarty, Thomas Mullaney, and foreperson Nettie Fogarty. (Larry Myers collection.)

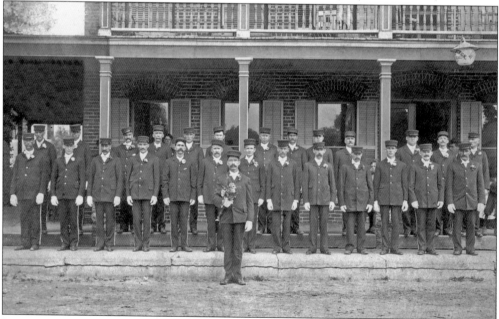

Port Leyden, like most communities in the North Country, has traditionally relied on volunteers for fire protection. In this c. 1910 photograph, the Major John S. Koster Hose Co. poses in front of Port Leyden's Central Hotel. Major Koster (1841–1921) was a pioneer in the pulp and paper industry—the first in North America to manufacture paper entirely from wood pulp. As a civic leader, Major Koster helped improve the Port Leyden Fire Department. (Bob Hindman collection.)

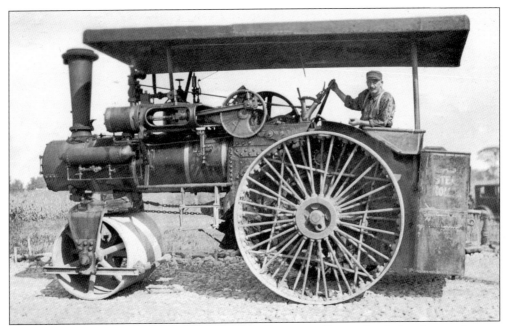

During the Great Depression, the Lewis County Emergency Bureau funded various projects to provide unemployed workers with temporary income. In 1934, one of these projects involved paving the East Road in the Town of Leyden with crushed stone. East Road, which is more or less parallel to Black River, runs north from Boonville to Lowville, and from there to Carthage. Though initially little more than an ox-cart path, it was the route by which many early settlers entered Lewis County. (Lewis County Historical Society.)

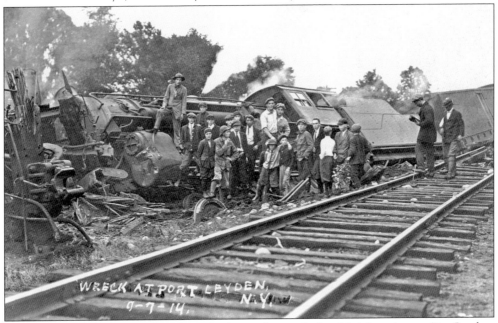

On July 7, 1914, a 19-car milk train from Carthage sideswiped a local freight train near Port Leyden. The two engines pulling the train were derailed and three cars were destroyed, but crewmembers suffered only minor injuries. (Lewis County Historical Society.)

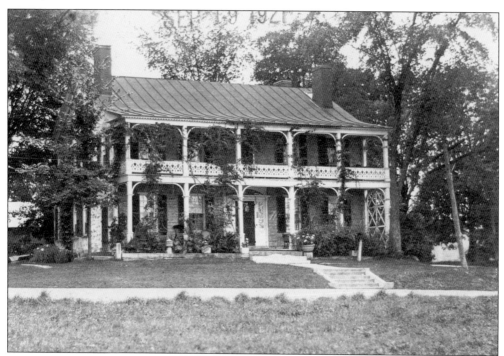

Jesse Talcott of Connecticut settled at Talcottville in 1795. Five years later, he began constructing this building with limestone quarried from nearby Sugar River. Around 1840, Thomas Baker acquired the property through marriage and operated the building as a tavern on the stage route between Utica and Sackets Harbor. Author and critic Edmund Wilson inherited the building in 1951. (Lyons Falls Historical Association.)

C. Hart Merriam (1855–1942) grew up at Homewood, his family's estate at Locust Grove, and later practiced medicine in the community before returning to his first love: natural history. In 1886, he became the first chief of the US Biological Survey and is remembered for having introduced the concept of life zones to the field of biology. In 1888, he helped found the National Geographic Society, and in 1899 he organized the Harriman Expedition to Alaska. His sister Florence Merriam Bailey acquired fame as an ornithologist. (Author's collection.)

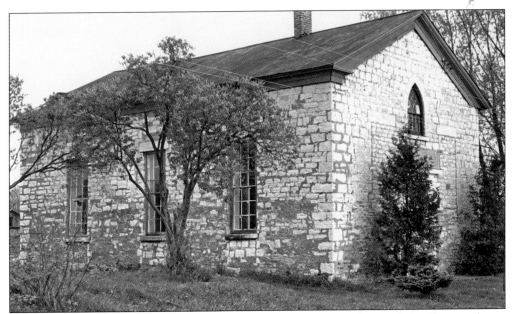

Organized in 1833, the Union Church of Collinsville (pictured) served the Episcopalians, Presbyterians, and Baptists, while the Calvinistic Methodist Church, organized in 1846, ministered to the large Welsh community in its native language. The Welsh church was built in 1855 but fell into disuse in the 1880s when the community, bypassed by the canal and railroad, began to decline. (Lyons Falls Historical Association.)

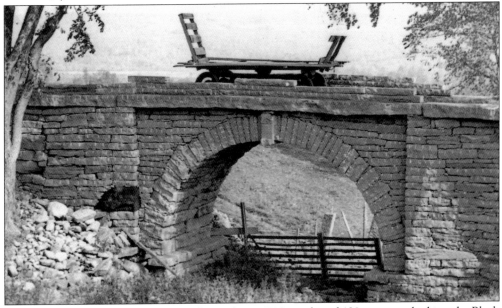

Collinsville is named for Jonathan Collins, who in 1799 purchased 188 acres overlooking the Black River Valley. Jonathan's grandson Charles, a great admirer of Scottish stonework, commissioned local mason Thomas Hughes to build this limestone bridge. The structure, which is basically decorative, bears the date 1878 and reputedly cost $10,000. Though he resided in New York City, Charles spent summers visiting his half-sister Caroline Hart Merriam, mother of C. Hart Merriam, in Locust Grove. (Lyons Falls History Association.)

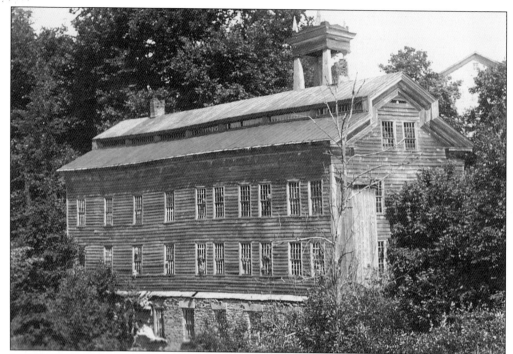

In 1831, Cadwell Dewey (1809–1882) erected a woolen mill on Mill Creek just east of Turin. The mill, which remained in operation until 1879, manufactured highly regarded kerseymeres and sattinets. The settlement of Deweyville had a store and residences for about 20 workers. In the late 1860s, a weaver might produce 300 to 400 yards of cloth in a month, earning between 6¢ and 7¢ a yard. (Lewis County Historical Society.)

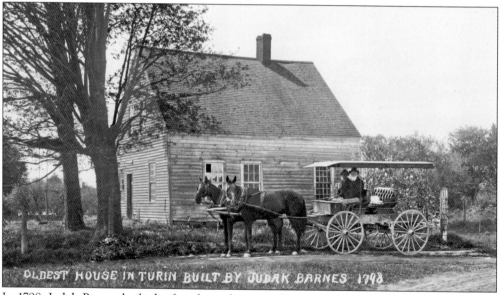

OLDEST HOUSE IN TURIN BUILT BY JUDAH BARNES 1798

In 1798, Judah Barnes built the first frame house in Turin near the intersection of East Main Street and East Road. The stage in this photograph conveyed mail from Lyons Falls to Turin via the New Road. This road that traversed the steep eastern slope of Tug Hill was not completed until 1910. The Barnes house was razed in 1914. (Town of Turin.)

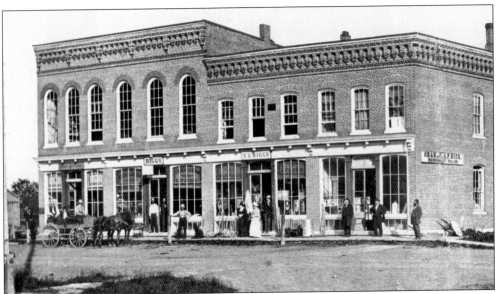

In 1833, Charles Giles Riggs set up as a tinsmith in Turin and within a few years was operating the first hardware store in Lewis County. In 1870, Riggs built a commercial block on Main Street (pictured) from bricks that he manufactured. The front on Main Street housed a furniture store, dry goods store, hardware store, and tailor shop, all run by Riggs and his sons Charles and Horace. Behind the brick block, Riggs maintained a carriage and a blacksmith shop. (Lewis County Historical Society.)

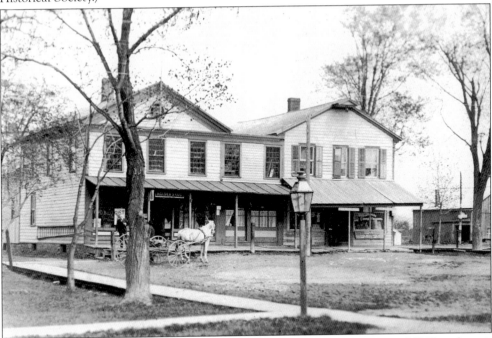

Emery B. Holden established a drugstore on Turin's North Main Street around 1840 and ran it until his death in 1878, when his sons E.D. and William D. Holden took over. In 1916, when this photograph was taken, Holden Brothers' Drugstore was on the left, and Ray Nickerson's grocery store was on the right. (Lyons Falls History Association.)

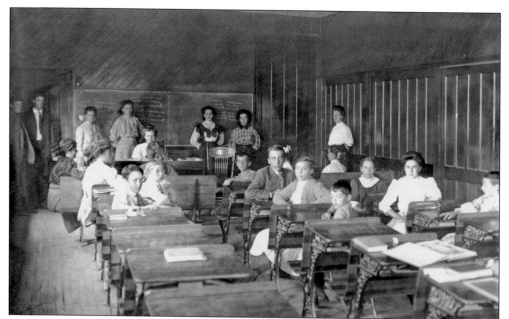

In 1846, the Turin Union Society built a school on South State Street at a cost of $2,350. During renovations in 1869, the school added a cellar and furnace, as well as the iron-and-hardwood desks seen above. For many years, the school was ungraded, with each student receiving individualized instruction. (Lewis County Historical Society.)

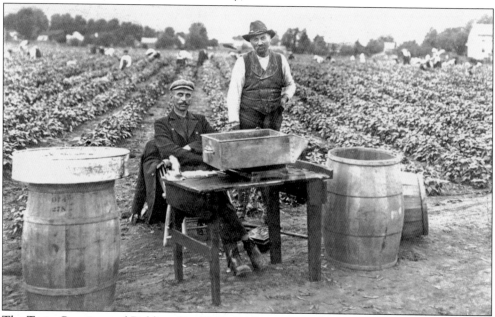

The Turin Canning and Pickling Co. (1885–1910) grew corn, beans, peas, pumpkins, tomatoes, and berries on land rented from local farmers. The factory was an important source of seasonal employment. In 1893, for example, 150 employees—mostly women—processed 1,200 wagonloads of corn, turning out 600,000 cans of finished product. The wages were 10¢ an hour. In this photograph, Andrew Hovey (left) and Thomas Kingsbury weigh produce on the edge of a bean field. (Mark Paczkowski collection.)

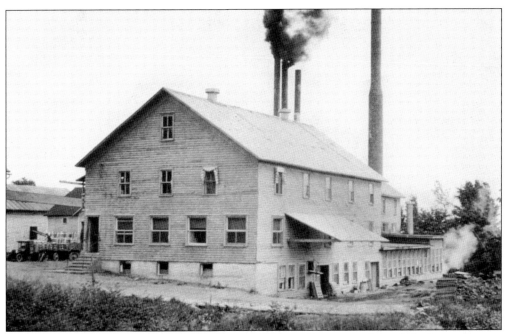

In 1918, Leon S. Miller, Harold Richardson, and Harvey Farrington formed the Lewis County Condensed Milk Co. Milk was trucked in from throughout the central and southern part of the county. By 1920, the company employed 60 people and was shipping enough condensed milk from Lyons Falls to fill a boxcar daily. In 1925, United Milk Products Corporation of Delaware purchased the plant and ran it until 1934. (Lewis County Historical Society.)

In 1847, the community of Turin acquired a town bell for $300. The bell originally hung in the Union Church but, proving too heavy for the structure, was transferred to a specially built bell house, which also served as a jail. The bell sounded at 7:12 a.m. and 6:00 p.m. daily, and it was rung to mark the deaths of local residents. In 1878, the bell was relocated to the new Village Hall. (Lewis County Historical Society.)

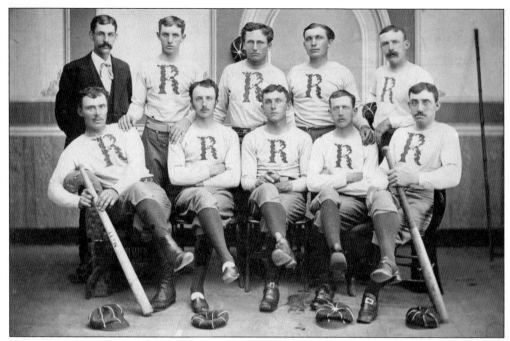

Between 1862 and the mid-1880s, the Turin Rough and Ready baseball team compiled a formidable record throughout Northern and Central New York. The Baseball Hall of Fame in Cooperstown honored the 1870 team by placing its photograph on permanent display. That team included, from left to right, (first row) James Allen, Ott Palmer, Hawley Kentner, Edward Gillette, and George W. Allen; (second row) Joseph Cythe, Evan R. Prichard, George Shepard, Garry Riggs, and John Devoe. (Town of Turin.)

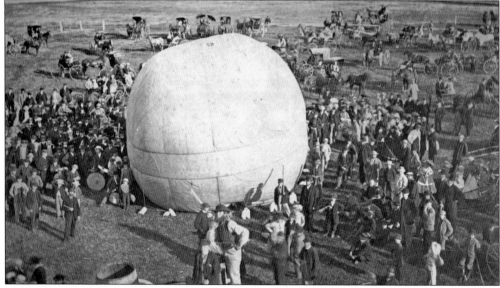

The Lewis County Agricultural Society organized in 1821. The society reorganized in 1841 and again in 1860. The annual fair was held at various places in the county until 1876, when Lowville became the permanent host. This photograph, taken in 1868, shows a balloon on the Turin Fairgrounds undergoing preparation for an ascent. (Lewis County Historical Society.)

Turin native Neil Litchfield (1855–1912) studied elocution at Cornell University. After receiving his degree, he taught school in Lyons Falls but was eventually drawn to the world of "polite vaudeville." Billing himself as the "Man of Many Faces," he performed dramatic readings on stage and did comedic impersonations of rural characters. With his wife, Stella, and daughter Abbie, he formed the "Neil Litchfield Trio," an immensely successful ensemble that drew large audiences in both the United States and Europe. (Mark Paczkowski collection.)

The Turin Cornet Band organized in 1876 under the direction of John E. Gladding. The band performed locally at the Music Hall, which was built in 1878, and at the Village Park bandstand, which was acquired from Martinsburg in 1881. (Mark Paczkowski collection.)

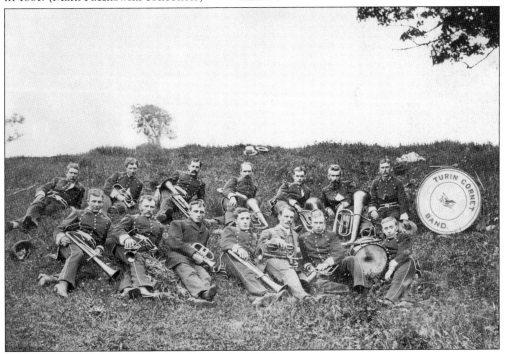

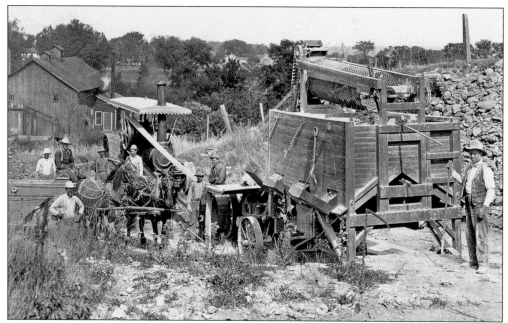

In 1909, the Town of Turin bought a steam traction engine. The following year the town purchased a stone crusher, bins, a 16-foot elevator, and an eight-foot screen separator for $1,600 from the Climax Road Machinery Co. of Marathon. (Arnold Weber collection.)

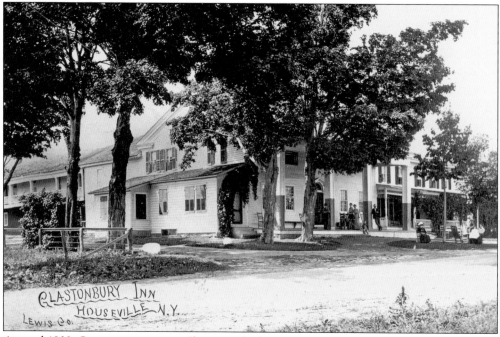

Around 1808, Connecticut natives Eleazer and Abigail House built the Glastonbury Inn in the settlement of Houseville. Under management of their grandson George, the hotel remained a going concern until 1883. Sometime thereafter, the establishment became a summer resort, attracting city residents who were seeking clean air and a healthy climate. The resort closed in 1903, no longer able to compete with Adirondack resorts. (Town of Turin.)

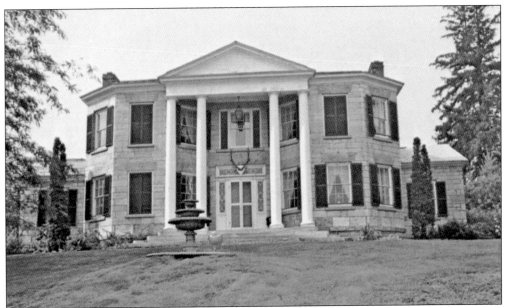

In 1792, William Constable paid £50,000 to acquire sole control of the Macomb Purchase. This tract included all the land out of which Lewis County would be formed. Constable died before he could visit his property, but his son William Jr. settled at Constableville, where he built Constable Hall (above) between 1800 and 1819. The structure was patterned after the mansion on his family's Irish estate. (Author's collection.)

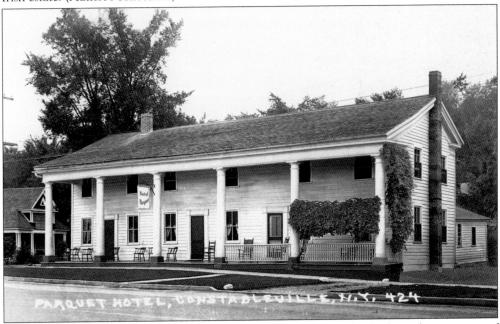

As agent for the Constable family, Nathaniel Shaler handled local land sales to farmers, most of whom hailed from Connecticut and Massachusetts. In 1796, Shaler erected a sawmill on Sugar River and built an inn, one of the first buildings in Constableville. In later years, the establishment was known as Hotel Parquet, named for John Parquet, who operated it from 1925 to 1954. (George Davis collection.)

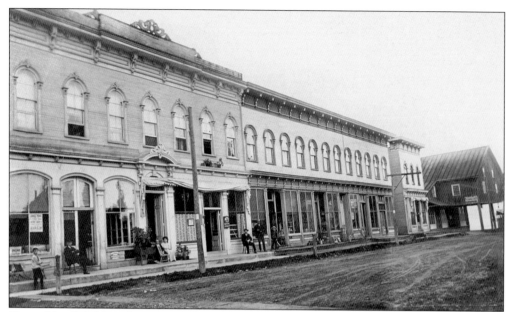

Constableville's Main Street once featured a handsome row of storefronts. Brothers John and James Doyle erected the second block from the left in 1876. The left side of that block housed Henry Bergman's Harness Shop, as well as Robert Cookman's Saloon and Billiard Hall. The right side of the block was home to Doyle's Hardware. The Doyles later established a chain of hardware stores, with locations in Lyons Falls, Port Leyden, Utica, Dolgeville, Newport, and Sidney. (Larry Myers collection.)

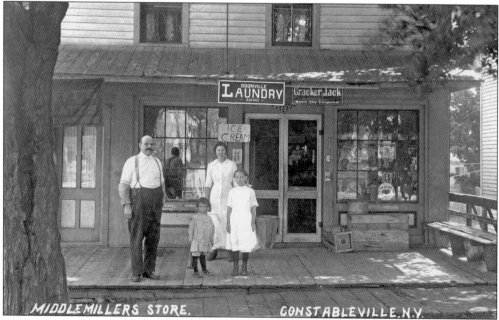

In 1912, retired cheesemaker Frank Middlemiller purchased W.J. Taylor's grocery store on Main Street in Constableville. He operated the store until his death in 1928. Standing to the right of Middlemiller are his wife, Theresa, and daughters Jennie (left) and Lorena (right). The store was a stop on Boonville Laundry's pick-up and delivery circuit. (Larry Myers collection.)

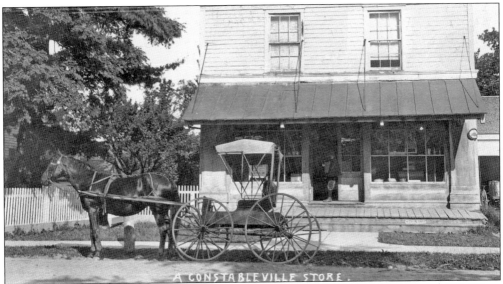

Seth and Mary Miller moved from Farmington, Connecticut, to Constableville in 1798. Their son Seth Jr. operated a mercantile on Main Street (above) from 1819 to 1870 and attained the rank of colonel in the state militia. Col. Seth Miller was part owner of the Canal Turnpike (in existence from 1823 to 1847) and later the Turin Plank Road (in existence from 1847 to 1855). As a director of the Ogdensburg, Clayton, & Rome Railroad (1853–1858), he hoped to bring rail service to Constableville, but—to the dismay of many—the railroad was never completed. (Larry Myers collection.)

In 1849, Orson Squire Fowler, architect and phrenologist, wrote a book extolling the virtues of octagonal dwellings. Inspired by this work, machinist Moses Eames (1829–1885) built this house on James Street in Constableville in 1856. An open-air porch encircles each story, and at the center of the house, a spiral stairway leads to an enclosed cupola on the roof. Eames owned a factory in the village that produced a wide variety of items, including pumps, cheese boxes, and wagon hubs. (Larry Myers collection.)

Located on the Tug Hill Plateau, the aptly named hamlet of Highmarket sits at an elevation of 1,857 feet. When the state suspended all public works projects in 1842, a number of Irish laborers building the Black River Canal chose to settle in the area as farmers. The nearest Catholic church was St. Mary's on the western edge of Constableville. When that structure burned down in 1879, the Irish Catholic community built St. Patrick's at Thompson's Corners (pictured). (Lyons Falls History Association.)

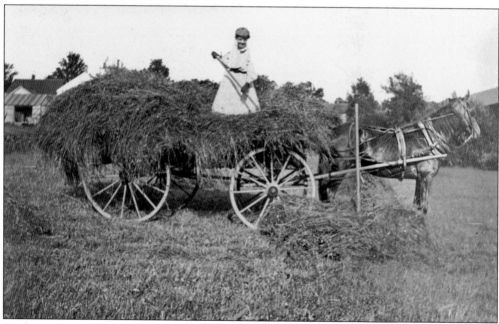

Settlement in the Town of Lewis began in 1798 with the arrival of several New England families. The population received a bump in 1831 with the arrival of 10 German families. By 1852, when the Town of Lewis was formed from Leyden and West Turin, foreign-born immigrants and their offspring constituted a majority of the population. As elsewhere in the county, farming and lumbering were the primary occupations. This 1910 photograph features Mary Pugh pitching hay on a West Leyden farm. (Author's collection.)

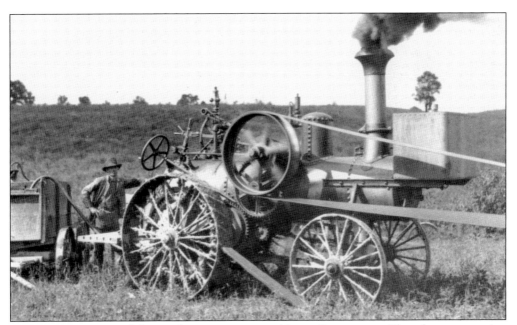

Steam tractors prepared the way for more maneuverable gasoline tractors. Though steam-traction engines were slow, heavy, and ill suited to plowing, they were useful in providing belt-power for threshing, baling hay, cutting silage, and pumping water. Enterprising individuals would invest in a steam tractor and perform contract work for area farmers. This photograph was taken near West Leyden. (Rita Higby collection.)

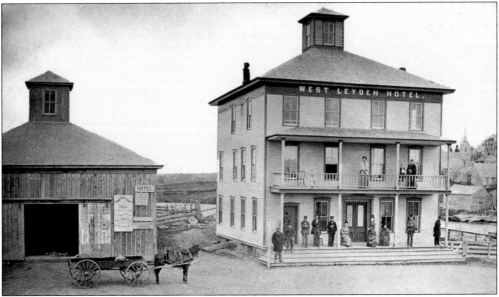

Philip Shankenberry built the three-story West Leyden Hotel in 1877. Eight years later, he removed the barn at the left and added a two-story, 36-by-100-foot extension, which served as a dancehall and roller-skating rink. The West Leyden Band practiced in the hotel and often performed for the skaters on Saturday nights. Balls on January 1 and July 4 sometimes attracted 500 people, which, in 1890, represented about half the people in the township. The structure burned down in 1898 and was rebuilt on a similar scale. (Lewis County Historical Society.)

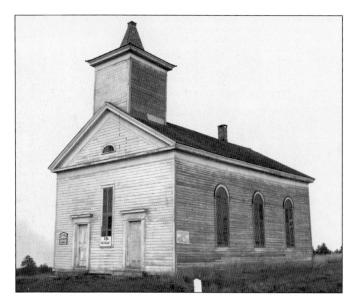

In 1854, the German United Evangelical and Reformed Church (later called St. John's Evangelical Lutheran Church) organized at Mohawk Hill, a former hamlet located between West Leyden and Constableville. St. Michael's Catholic Church (1853–1953) was also located at Mohawk Hill. From 1882 to 1907, St. Michael's operated a parochial school and at various times sponsored missions at Fish Creek, Prussian Settlement, and West Leyden. (Lewis County Historical Society.)

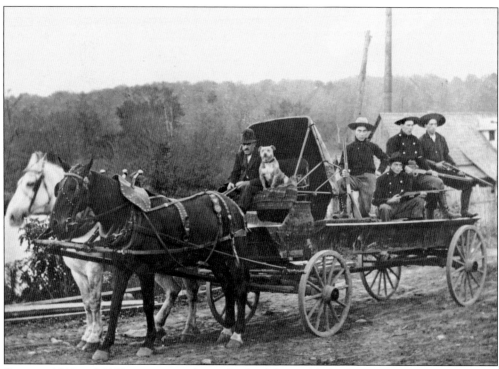

Between 1840 and 1860, an estimated two-thirds of the world's bird's-eye maple was cut in Lewis County. Some of it came from the settlement of Swancott's Mill, named for David L. Swancott, who built a sawmill on Fish Creek in 1843. In this photograph, four young men, rifles ready, head off to the hunt. The name "Fish Creek" commemorates the great number of Atlantic salmon that once spawned in the stream and which the Iroquois snagged in their weirs. (Ed Fynmore collection.)

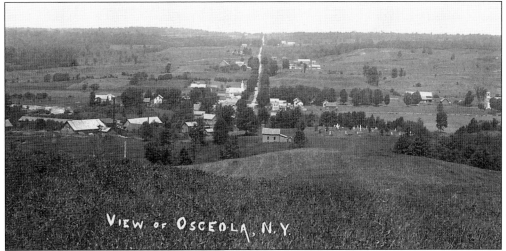

Osceola lies in the Salmon River Valley, a favorite hunting area of the Iroquois. An Iroquois creation myth holds that Sky Woman fell from the heavens and was received on the back of a great turtle, where, with the help of other animals, she formed the earth. According to tradition, this took place in the region between Salmon River and Sandy Creek in Pinckney. Salmon River, visible at center left, is recognized as one of the great coho and king salmon fisheries in North America. (Larry Myers collection.)

Investors incorporated the Rome & Osceola Railroad Co. in 1908 with the intention of extracting an estimated 375 million feet of lumber from southwestern Lewis County. The rail line was to run 25.5 miles from Rome to Swancott's Mill in the Town of Lewis. Extensive grading was completed, but the project was finally abandoned in 1924. This photograph shows an American Railroad Ditcher, a piece of equipment that could be used as a steam shovel or as a pile driver. (Town of Osceola.)

DISCOVER THOUSANDS OF LOCAL HISTORY BOOKS FEATURING MILLIONS OF VINTAGE IMAGES

Arcadia Publishing, the leading local history publisher in the United States, is committed to making history accessible and meaningful through publishing books that celebrate and preserve the heritage of America's people and places.

Find more books like this at
www.arcadiapublishing.com

Search for your hometown history, your old stomping grounds, and even your favorite sports team.